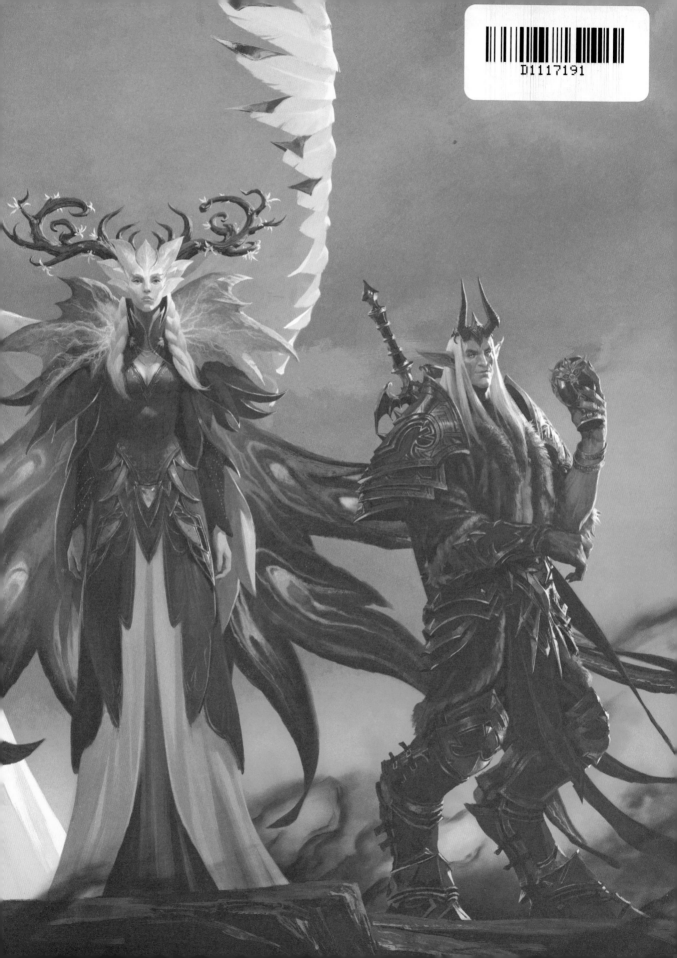

GRIMOIRE OF THE SHADOWLANDS AND BEYOND

GRIMOIRE OF THE SHADOWLANDS AND BEYOND

Sean Copeland • Steve Danuser

© 2021 Blizzard Entertainment, Inc. World of Warcraft, Blizzard, and the Blizzard Entertainment logo are trademarks or registered trademarks of Blizzard Entertainment, Inc. in the US or other countries.

Published by Blizzard Entertainment. Blizzard Entertainment does not have any control over and does not assume any responsibility for authors or third-party websites or their content.

Library of Congress Cataloging-in-Publication Data is available.

Case / Jacket
ISBN barcode: 978-1-950366-50-7
Manufactured in China

Print run 10 9 8 7 6 5 4 3 2 1

CONTENTS

Overseer Ta'readon:

Living mortals surge into the Shadowlands, and yet we maintain suboptimal information to properly transact with them. We remain ignorant of not just their numerous identities and cultures but also what these living beings introduce to the new equation facing Death—the living interacting with a reality not meant for them to perceive, let alone to alter its sundry functions across the afterlives they tread.

While we flounder, the Ve calculated the potential benefits and weighed their existences as a sufficient investment to brave the Maw and seek out these mortals—significant enough to execute an operation despite nigh impossible levels of hazard and liability. This missive serves as official confirmation of our concerns: Cartel Ve has successfully secured a claim within the Maw.

Details are scarce due to the small number involved in our rival's expedition. Nevertheless, what I have been able to ascertain on the topic thus far is as follows:

 Cartel Ve, cognizant of the risk, financed an exploratory venture into the Maw to gain access to an untapped source of information, untouched resources, untold influence, and the living mortals inexplicably able to traverse it (now called "Maw Walkers").

The venture was an unmitigated success. Shortly after confirmation of a defensible position was acquired, all communication with Ve agents was severed.

Ve'nari, the broker in charge of the expedition, arranged the elimination of her fellow cartel members to secure exclusive access to their newfound resources.

 Through these actions, Ve'nari positioned herself as the sole ally (and, therefore, the only available point of commerce) of the Maw Walkers—living mortals unbound by the judgment of the Shadowlands who hail from a world known as Azeroth. It is a name you will come to know very well indeed by the conclusion of this report, as it appears in my findings time and again.

It is imperative that our own cartel avoids being at a further disadvantage to our rivals. The Ve's success proves there is too much that remains unknown to us about Death's interactions with the mortal plane and those who inhabit it. I shall endeavor to learn all I can about the Azerothians and the afterlives in which they associate. The results shall be compiled in this grimoire for the cartel's records.

While accuracy will of course be my utmost priority, much of the information I intend to convey will be dependent upon the veracity of my sources. Despite the best efforts of all our cartels to ingratiate ourselves to new arrivals in Oribos, the living remain ever wary. Perhaps the appearance of our encounter suits, though designed to be aesthetically pleasing to mortal sensibilities, are too unfamiliar. Or it may be that our projected demeanor, painstakingly crafted to be seen as friendly and appealing, was a miscalculation.

Of secondary concern is the difference in nomenclature that exists between our kind and the mortals. While we, of course, know Death to be the eternal force of magic woven throughout the very fabric of the Shadowlands and beyond, mortals have an entirely different—and shockingly obtuse—interpretation. They use the word "death" to signify the end of their existence within the mortal plane. My apologies, Overseer, if you find that revelation to be as distasteful as I do. But I fear that to accurately convey information on mortal perceptions, I must, from time to time, include observations from their own flawed perspective.

The Ve plotted a dangerous path to monopolize our new associates and were ultimately betrayed. We must move quickly, for we are not alone in our attempts to plumb the depths of Death to unlock its countless mysteries. May you find this treatise on Death and our Azerothian associates inspirational, Overseer. In the brief span they have spent among us, the living have proven significant in altering the very future of the Shadowlands.

Yours in influence,

Ta'lora

CHAPTER 1

RITES OF THE DEAD ON AZEROTH

When a living being's existence in the mortal realm concludes, the corporeal remains that the soul once occupied become the responsibility of companions and kin left behind. The kyrian have no need for the temporal trappings of the soul when they come to ferry the anima-laden parcels to the Shadowlands. But what rites, rituals, and trinkets are used to celebrate the departed's journey into the welcoming arms of Death? Many cultural examples exist that can be cited within this resource, but as our interests pertain to the world of Azeroth and its mortal children, I have documented notable details from that perspective. All in all, funerary rites of this specific world thus far appear to be held in three manners: burial, cremation, or a hybrid of the two.

BODY DISPOSITION AND TRADITIONS

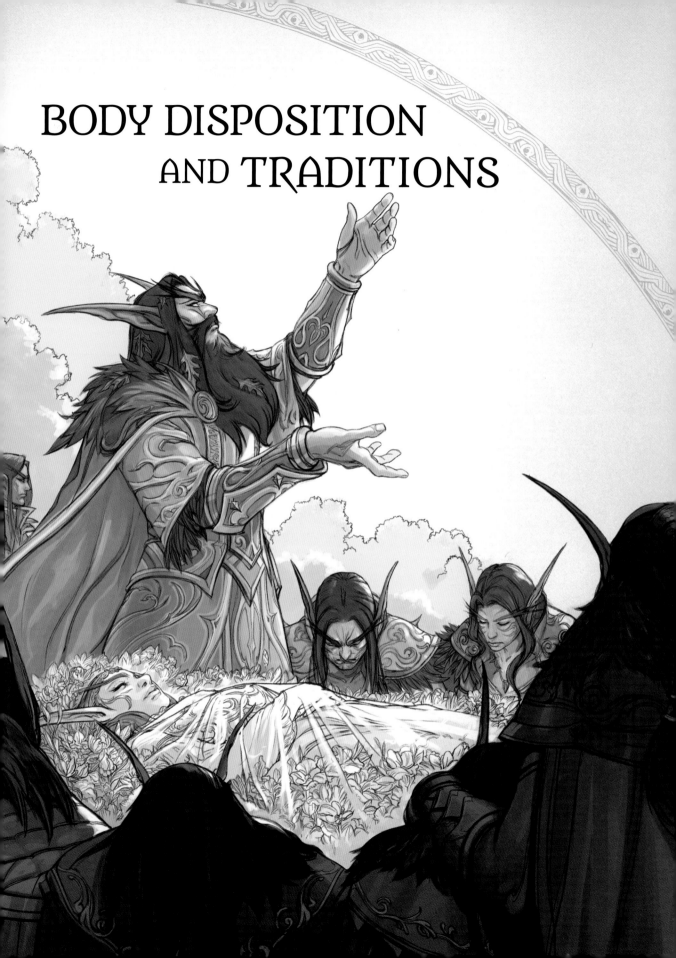

As the spirit has departed its mortal vessel, let that vessel now return its strength to the world. The World Tree welcomes this child. The world welcomes its child back.

I will begin my examination with a race known as night elves, or KALDOREI. Night elven culture is deeply connected to the natural environment in which they surround themselves. These humanoids prefer a form of interment that mirrors their ties to nature.

The body of the deceased individual is ritualistically cleansed in pools of moonlit water by priestesses of their faith. Their healers appear to combine arcane and nature magic to mend the dead body for a final viewing. The name of the departed is sung by the priestesses from their holy temples, devoted arias that highlight the life and sacrifices of the fallen they mourn as a burial shroud is draped around the deceased. Upon a bier draped with flowers, the remains are brought to a grove of trees (organic flora of which this culture seems especially fond).[1]

The remains are then placed upon a patch of grass, and another—one who can seemingly manipulate the energies of nature—takes part in the rite to spur on the growth of plants around the corpse. From this rapid growth springs forth a wide spectrum of colorful blooms all around the body. First to outline the empty vessel, then ultimately encasing the body entirely. What was left behind now fulfills its place in the cycle of those inconveniently bound to Life.

One unique trait of these night elves is worth particular note: while most of their people's souls are borne across the veil as expected, certain night elves may also linger in the mortal realm in a soulshape they refer to as a WISP. It is this author's opinion that this phenomenon is caused by the soul's intrinsic bond with the magical nature of its home forest, thus creating a tether that allows the wisp to remain among the living. Though, it should be acknowledged, I cannot entirely rule out the interference of Elune, their revered deity, in this matter. As we well know, beings of her origin cannot, under any circumstances, be trusted.

1 Additional research into flora such as the night elven alor'el (known in their native language—Darnassian? verify later—as the "lover's leaf") and the moonpetal lily seem especially lucrative to acquire for future ventures.

And if you're wondering why I contractually required you all to lower my glorious casket—the likes of which none of you could ever hope to afford—into its resting place, it's so my body could experience the familiar sensation of you letting me down one last time.

In direct opposition to the graceful final rites of the night elves are the gaudy practices of the GOBLINS. I base this conclusion upon conversations with a soul I encountered in Revendreth named Donais.

This loquacious mortal insisted that he was something known as a "trade prince" in life—a title of apparent great meaning in the goblin society of Azeroth. He spoke at exhausting length of his many accomplishments, paramount among them being the obscene amounts of currency he had acquired for the purpose of lording his prosperity over his associates. It was this massive wealth that he harnessed to fund his grand and final sendoff, despite the fact that none of what he'd accumulated could accompany him to the realms of Death. Simply stunning.

In goblin society, status is supreme and directly correlates to the size and extravagance of the funeral. In addition to the quantity of mourners, goblins include revelry and entertainment as crucial parts of the proceedings. Donais had personally picked out the musicians and refreshments and even drafted a list of burial gifts he demanded prior to the expiration of his mortal body. The trade prince had his needlessly ornate (and presumably heavy) coffin ferried to his burial site by dancing pallbearers.

The highlight of goblin funerals is the reading of the list of assets that belonged to the goblin in life. While mortals commonly bequeath their possessions to kith and kin who survive their passing, it should be noted that there is no division of goods in this case. For goblins, it is preferable to be entombed with their belongings. This act is performed in full view of those the deceased goblin considered rivals, enemies, and even family. (It is unclear how much, if any, differentiation exists between these three groups.) Inspiring feelings of jealousy is wholeheartedly the intent.

Donais gloated in the retelling of the sheer ordeal his laborers had getting the mountain of gold he had saved for his burial trove, an amount intentionally greater than the capacity of the coffin. His rather peculiar final wish was read and enforced to the letter: a final wish that ensured there were a specific number of associates and family members in attendance to lower him into his grave.

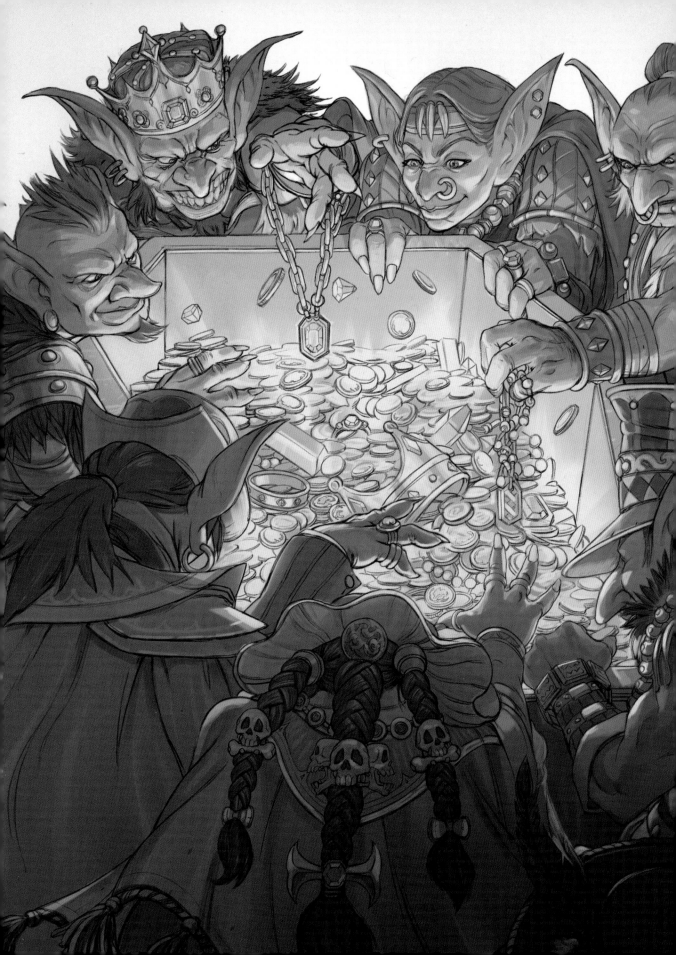

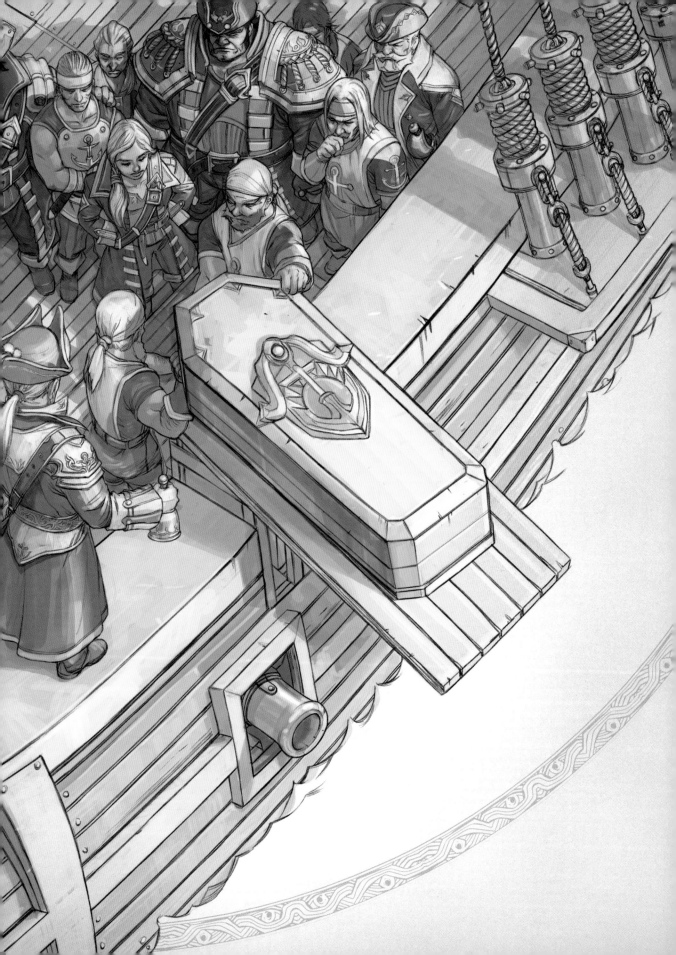

May the abyssal depths welcome your weary soul. Ebb and flow, until your spirit's woes are washed clean. Fear not for the waves, for they judge not your surface. Wonder not for whom the lighthouse shines. It shines for thee. Let your heart rest in placid waters.

Cultural variance of final rites appears to be common, even among members of the same race. An example of such an instance lies with the humans of Azeroth. While most seem to prefer burial beneath the earth in allocated plots of land (or "graveyards" in their native language), one nation referred to as KUL TIRAS instead allows their dead to sink beneath their seas. The holy persons of the kingdom, known as tidesages, claim to heed the whispers of their world's elements, particularly those of the waves. Over time, the Kul Tirans established a tradition to perform their burials at sea.

These humans believe particular rituals and relics are required to successfully release the spirit of the deceased into the afterlife. (An absurd notion, of course, but these humans appear to be a particularly superstitious culture.) Of all the artifacts, an ornate bell, known as a Dead Ringer, is of greatest importance.[2] The body of the departed is meant to sink, and the ringing of the bell enables their soul to rise above the depths. A full account of their practices was shared for a trifle of anima from a mortal soul known in life as Brother Parker.

2 Displays of a specific variant of local flora known as "star moss" is of unique importance in the provision of Kul Tiran final rites, in that a bloom is given to all mourners to set loose on the waves. This star moss is of no astrological significance yet is found in all retellings of former Kul Tirans. Relevant when transacting with these souls.

Every morning, An'she bleeds. He sacrifices part of his light to let us know that dawn is coming. But he doesn't do this alone. The yeena'e (translated from Taur-ahe, "those who herald the dawn") help him. I'll build a pyre and light it at dawn so that An'she can watch my boy's passing.

It felt like serendipity: a chance meeting with a TAUREN soul who once was the bondmate of a famed tribal leader. She agreed to share her story without need of compensation—a bargain price that I accepted—and I listened intently. Tamaala's life was ended by an incurable illness, but her spirit remained in the mortal world to keep watch over her living partner and their son.

When asked what force she employed to delay the embrace of the kyrian, her curious response was given without hesitation or any hint of regret: "Cairne never left my side in life, and I wouldn't leave his in death." Further inquiries did not yield a more objective assessment of her situation, so I had little choice but to politely accept her ignorance.

Their people, the Bloodhoof tauren tribe, were once nomadic folk. These wanderers honor their dead by constructing large funeral pyres to incinerate the corporeal remains of the deceased. There are several ceremonies and traditions across the individual tribes and families surrounding the burning. One of these traditions involves an ancient burial site known as Red Rocks: a meditative place for the tauren, reported to be where their heroes are cremated. The resulting ashes are scattered to the winds, where the tauren believe they rejoin their local deity, their Earth Mother.

I was also interested to learn that certain tauren are given the title of "spirit walker" and claim to have the ability to communicate with ancestral spirits. They insist that the sacred nature of sites such as Red Rocks enables souls to cross the veil and interact with the living for a short duration of time. Investigation into this phenomenon has resulted in little tangible evidence as to the veracity of these claims, however. While I do not find this race to be inherently skilled at deception, I cannot rule out the possibility that they are susceptible to mass delusion.

As she finished spinning her yarn for me, Tamaala clarified that she has not been fully reunited with her beloved yet—she claims that after a brief meeting upon her partner's passing, he has chosen to await their son as she awaited him. She then stated she wanted nothing more than to walk the great plains of their verdant ancestral afterlife as a family once more. A quaint notion, if not entirely credible.

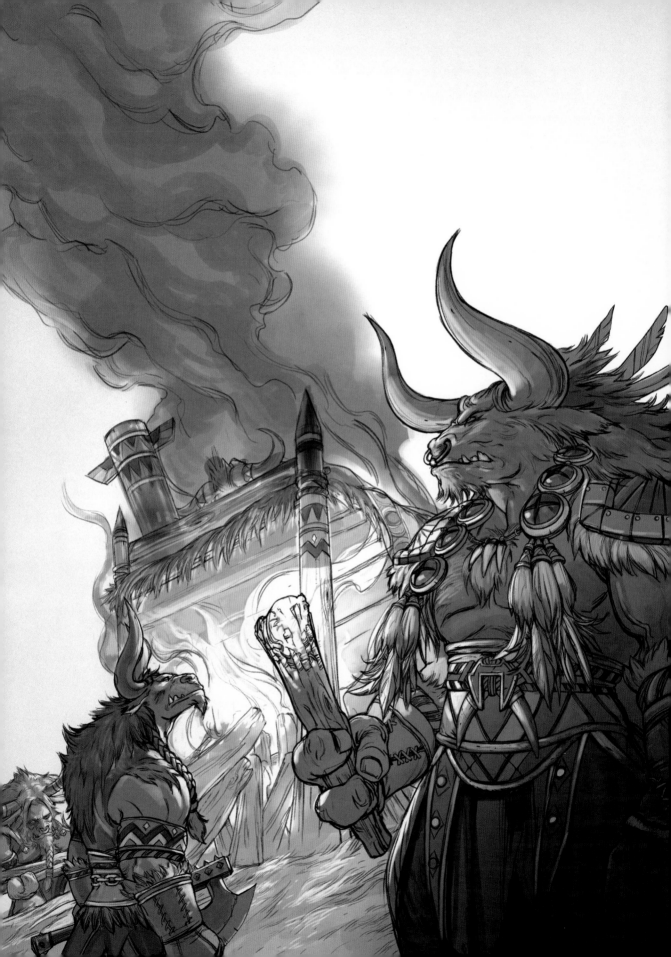

FORCES OF DEATH ON AZEROTH

Amusing as these mortal superstitions may be, I have learned of verifiable cases of the influence of the Shadowlands taking root on Azeroth. The first example I shall cite is that of a prideful servant of the titans named ODYN, who desired to prevent the bravest among his followers—a hardy, warlike race known as vrykul—from crossing over into their justly earned afterlives at the conclusion of their mortal existence. Odyn sought a means of conveying these spirits to his seat of power, the haughtily named Halls of Valor. So desperate for adoration was this selfish keeper that he struck a bargain to trade one of his eyes for the knowledge to create winged soul-bearing beings he called VAL'KYR—a name that rings more than slightly familiar to those of us born to the realms of Death. Truly a cautionary tale of the cosmic forces of Order going unchecked!

However, those aligned with Order were not alone in their misguided ventures to harness the power of Death. The demons of the Burning Legion have sought to conquer the world of Azeroth on multiple occasions, and one vessel they employed to achieve their ends was an entity known as the Lich King, a mortal spirit bound to ice and armor and given command of a vast undead army called the Scourge. Though the lords of the Legion were led to believe that this Lich King was their own creation, recent revelations would suggest that the forces of Disorder were manipulated into helping the Jailer's influence reach out from the Maw into the mortal plane.

These are but two examples I have thus far been able to substantiate, but I sincerely doubt that they are the only ones we will discover as we continue our parlance with the living mortals from this fascinating world.

Upon the termination of its physical vessel, the mortal soul will be conveyed into the afterlife unless a kyrian Watcher determines that the soul remains tethered by a sufficiently powerful force. In such exceptional cases, the Watcher may nudge that soul back into the mortal plane, or the soul will be given over to the force that claims it.

When Odyn set out to realize his vision for the
Halls of Valor and the Valarjar, he needed to create Val'kyr,
spirits capable of preserving worthy souls for all time.
Helya was not interested in becoming a Val'kyr.
No one volunteered, in fact. And so Odyn transformed
her and others into Val'kyr against their will. For many
years, Helya had no chance to seek vengeance. When
the opportunity arose, she took it without hesitation.

CHAPTER 2
ENTERING THE SHADOWLANDS

To ensure the comprehensiveness of this grimoire, let us review how the prodigious system of souls entering the afterlife and receiving judgment worked flawlessly for eons prior to its current and wholly altered state. This historical exercise shall, if nothing else, serve as a reminder that every broker cartel must remain mindful of change and be prepared to adapt to its unpredictable repercussions.

Due to the inherent fragility of the mortal corporeal form, the myriad of ways in which an existence can be ended is nigh incalculable. But as we know, what happens afterward is easily quantified.

DELIVERING THE SOUL TO THE ARBITER

Once a soul is in the charge of the kyrian, the soul is ferried across the veil between Death and Life, bearing witness to what the mortal soul would consider seemingly impossible sights as they are borne aloft to ORIBOS—the destination that awaits all souls whose time in Life has ended.

Quantity and potency of anima—that precious energy bound within each mortal soul accumulated through its deeds in life—varies from one soul to the next. Since the dawn of known existence, the judgment of where their anima is ultimately destined has fallen to the most implacable of the Eternal Ones: the towering ancient being known as the ARBITER.

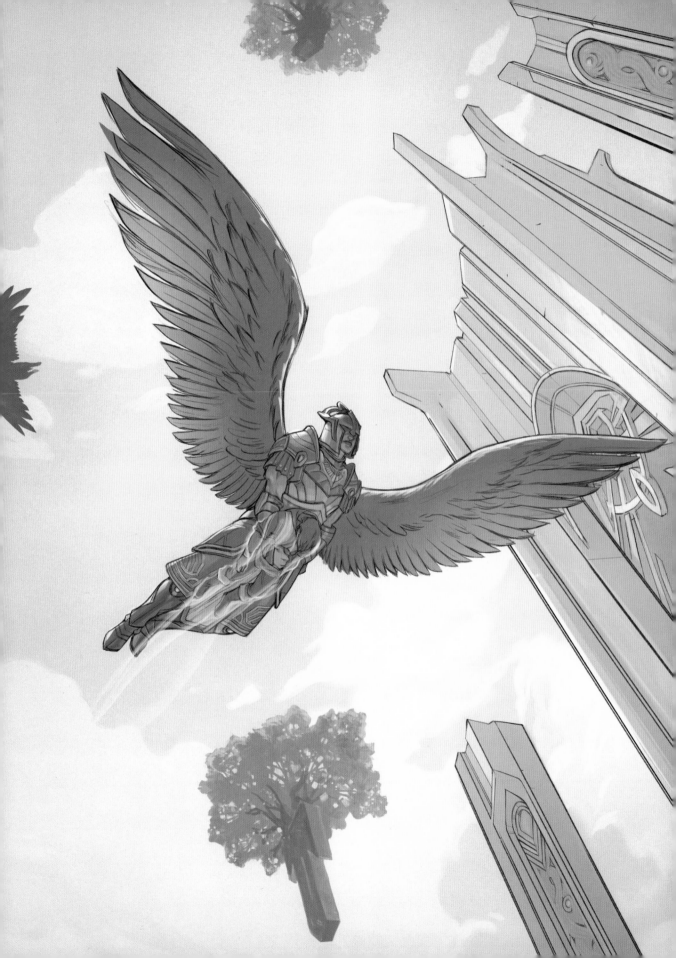

JUDGMENT

To use a mortal metaphor, each soul is but a drop of water amid a rushing rapid racing toward the Arbiter. And yet each drop was once carefully measured and diverted to a specific place amid an infinite number of others in the ocean of Death. Yet now, matter the benevolent fate the soul lived in life; once placed within the soul stream, its destiny turns to tragedy. All that now arrive are damned to dwell within the cold embrace of the Maw.

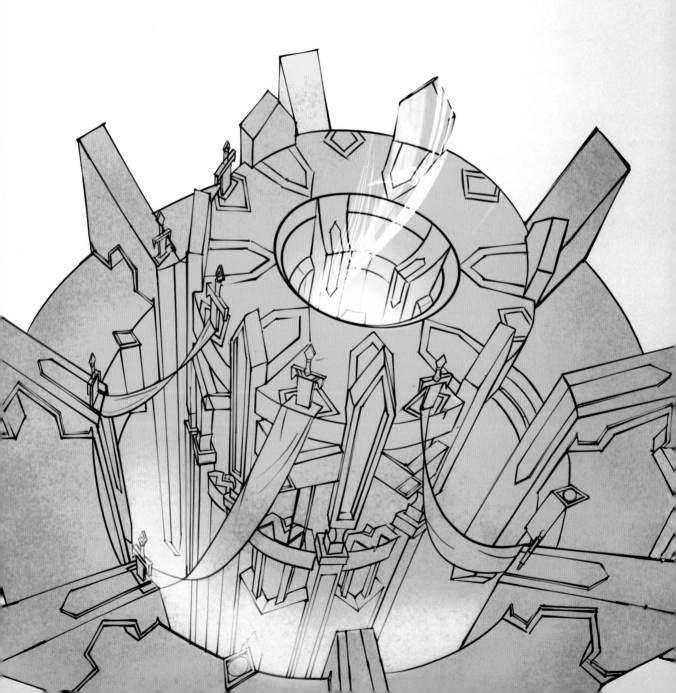

Before the breaking of the Arbiter, a veritable throng of kyrian would deposit souls into the ever-flowing soul stream that conveyed them into the Arbiter's chamber. After all, with the considerable number of worlds occupying the mortal plane, and the fact that some percentage of their population's existence is constantly in the throes of termination, the result is a massive and constant influx of new souls into the infinite afterlives of the Shadowlands.

Even our most precisely calibrated instruments were incapable of measuring the minute fraction of existence that the souls in these currents experienced before the Arbiter. Yet it was apparent that in this wondrous sliver of time, the Arbiter bore witness to their entire history and set them on their justly deserved path. So vast and varied are the uncountable afterlives that we have no hope of cataloguing them in their entirety. Let us, therefore, focus upon the realms most fundamental to the function of Death as the underlying force in our cosmos, where mortal souls were sent to partake in sacred covenants—Ardenweald, Bastion, Revendreth, and Maldraxxus—and the loathsome clutches of the Maw.

FIVE AFTERLIVES
OF NOTE

To ARDENWEALD traveled souls bearing a close affinity to nature and the creatures of the wilds. Within the eternal forests of the realm, the Winter Queen and her faithful night fae upheld the endless cycle between Death and Life, restoring those seeking respite within her many groves.

In BASTION, the dutiful were delivered on shimmering wings to kyrian caretakers and trainers—a reward, of sorts: a brief mortal life of selflessness in exchange for an eternity of service to those worthy of ascension. Kyrestia the Firstborne, the steadfast Archon, forged the path for her kyrian to follow, each tirelessly training to bear mortal souls across the veil to stand judgment before the Arbiter.

REVENDRETH is where the prideful deemed worthy of one final chance at redemption were sent to be cleansed of their burdens or face oblivion. Sire Denathrius, former master of the venthyr people, was installed to attend to the most desperate, sin-burdened souls and provide them the chance for rehabilitation. But as we now know, it was a duty long abandoned in favor of his pact with the Banished One. Denathrius is to blame for the anima drought and the suffering of countless mortal souls—conditions that, however unfortunate, led to certain opportunities for our cartels to leverage.

To **MALDRAXXUS** were dispatched those souls who had insufficiently slaked their thirst for conflict in life, affording them the chance to prove their worth within the immortal army of the necrolords. The Primus and his five great houses safeguarded the Shadowlands against any outside force foolish enough to dare war against it. Or so they did, until the Primus disappeared and the great houses all but fell to ruin.

And lastly, let us consider the inescapable pit of agony known as **THE MAW**. If the details of its origins were ever recorded, such knowledge seems to have been purged from the annals of history. The darkest, cruelest souls unfit for any hope of reprieve were cast down into the very heart of despair and hopelessness. Now, as aforementioned, with anima in short supply and the Arbiter broken, all souls—fair and vile alike—face the torment of the inescapable Maw and its malignant Jailer. Its secrets remained unknown for countless eons, until its confines were breached by the Maw Walkers of Azeroth—and by our Ve cartel competitors.

For such a grand and majestic thing, every detail of the soul stream is accounted for. Its currents of countless souls drift toward the Arbiter, each individual soul tabulated and archived by the attendants and their Fatescribe.

Brokers

Since we first noted them in Oribos, it became apparent that living mortals fixate upon their physical appearance (including, for inexplicable reasons, the acquisition of equipment they find aesthetically pleasing). Yet no matter the configuration or complexity of the mortal flesh, it is merely a vessel for the soul. Entwined with this soul is the most precious and profitable resource of the entire Shadowlands: ᗅᑎᎥᗰᗅ.

Anima

As we brokers have come to learn through our transactions with the various realms, the uses for anima differ between each afterlife. Anima sustains their lands and native denizens, and yet that barely scratches the surface of its potential. And while it is true that anima is generated exclusively by mortal souls, it should be noted that there is considerable variance in the quantity of anima produced by each soul.

Take the example of a mortal who lived a quiet, unremarkable life of little consequence. Such a modest existence produces an equally modest amount of anima. Should a mortal soul live a life considered significant or extraordinary—whether for good or ill—it will generate and retain copious amounts of anima. In short: the more remarkable the life, the more anima that will result from it.[3]

3 Δ Anima $\propto \Sigma$ Exp. (Life)

Upon arriving in their appropriate afterlife, each mortal soul will relinquish their anima to benefit their new home and those aligned to it. In some realms, the anima will be offered willingly; in others, it will be stripped from their being. Of the afterlives I have observed, Revendreth has mastered the most efficient (and, some might argue, the cruelest) process of doing so. Given or forcibly taken, one fact remains true no matter the method: anima is needed in every corner of the Shadowlands for the mechanism of Death to carry out its eternal function.

The process of mortal souls crossing the veil, fulfilling their purpose, and giving their anima has endured without interruption for uncounted ages. As far back as our records indicate, anima has always existed in abundance. Our cartels saw little value in maintaining a stock of this resource, as no afterlife ever expressed a desire for our assistance in acquiring it.

Until they did. Recently, trade in anima has proven monumentally profitable. Though as living mortals have proven their ability to rescue souls and supply them to the covenants, it is possible that anima's value as a tradeable resource has peaked.

In preparation for this discourse on the harvesting of anima, an intriguing note has come to light. Some mortals speak of primal forms of magic they refer to as the elements, which are harnessed in a ritualistic practice called shamanism. Two of these elements are known as spirit and decay, which may have an influence on the soul's generation of anima. The exact nature of this relationship is unclear, and extensive research would be required to prove whether this is accurate or merely a hoax perpetrated by zealots. Low magics, as well as those who practice them, are inherently unreliable.

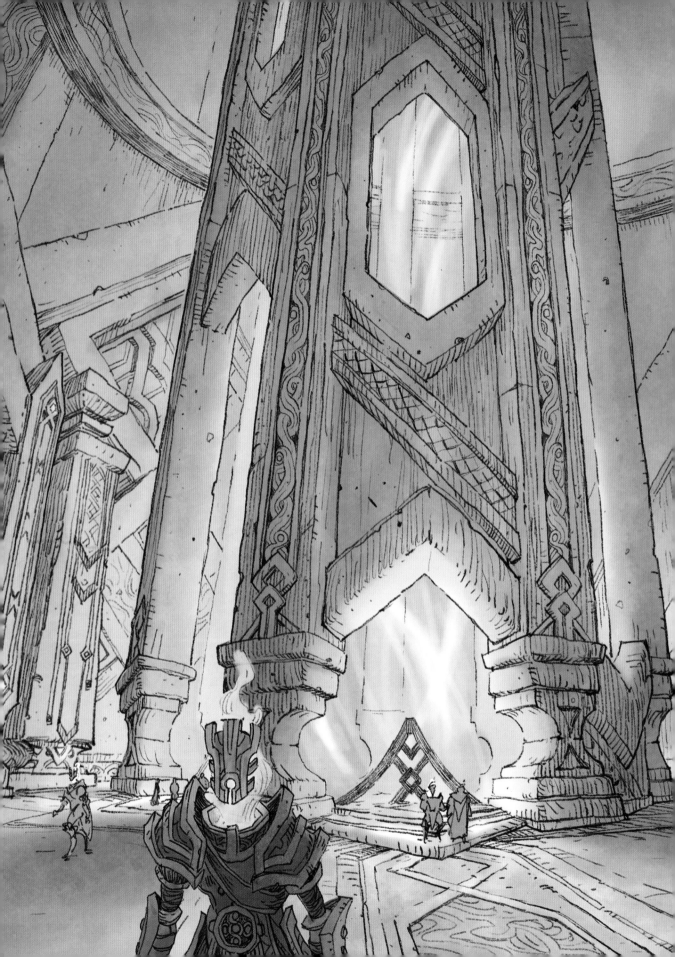

CHAPTER 3
ORIBOS

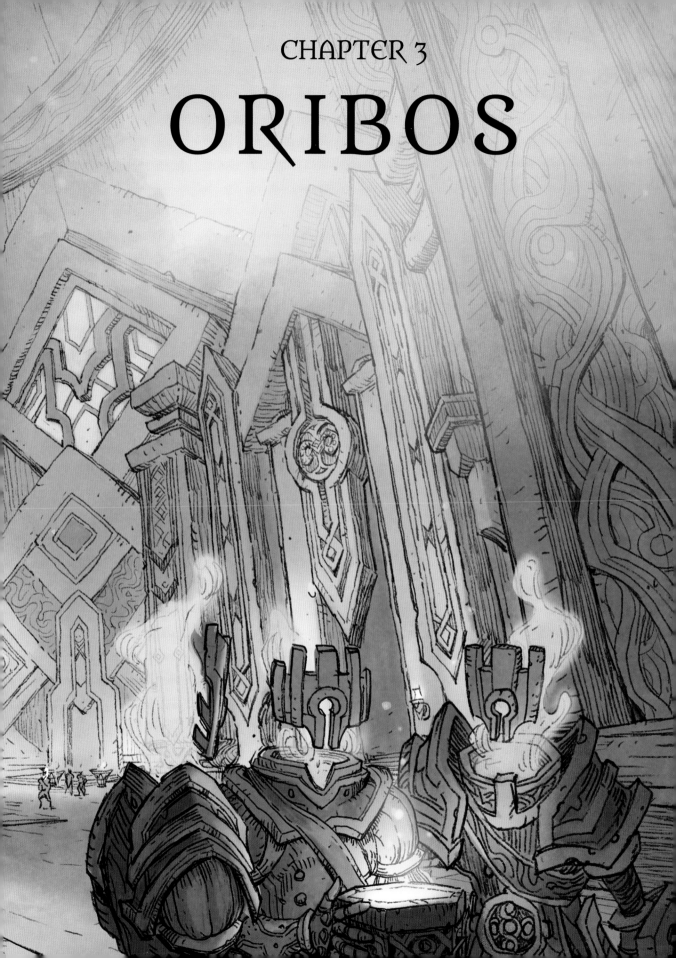

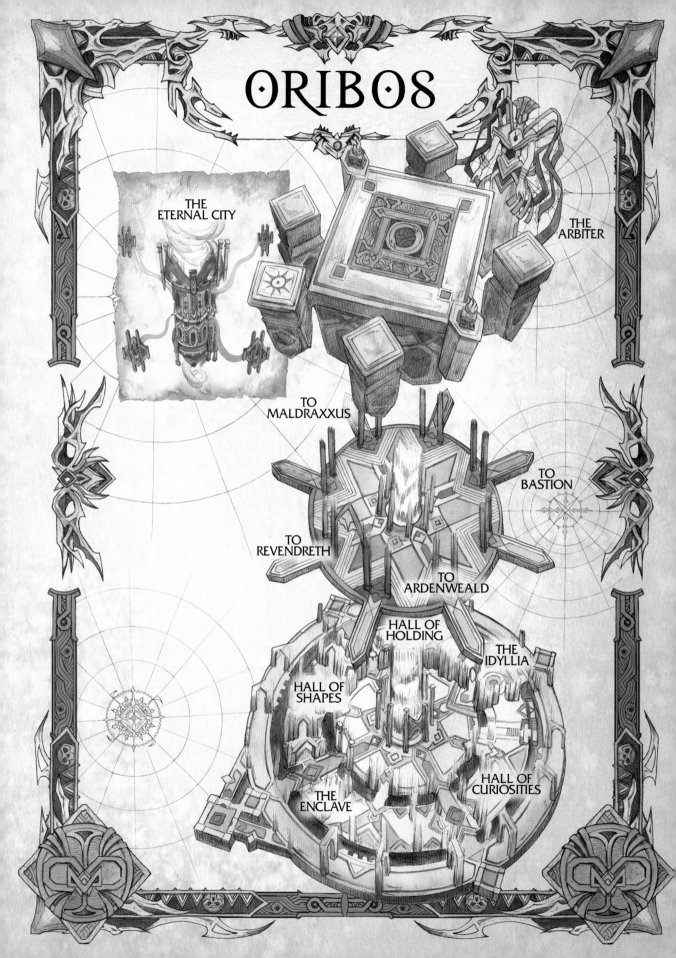

ORIBOS

THE
ETERNAL CITY

THE
ARBITER

TO
MALDRAXXUS

TO
BASTION

TO
REVENDRETH

TO
ARDENWEALD

HALL OF
HOLDING

THE
IDYLLIA

HALL OF
SHAPES

HALL OF
CURIOSITIES

THE
ENCLAVE

Since embarking upon the first of our expeditions to chart the afterlives of the realms of Death, we brokers dreamed of setting foot in the Eternal City of Oribos—the resplendent heart of the Shadowlands itself. Everything we had learned from our travels indicated that Oribos was a place of boundless knowledge, where ages could be spent learning from the spirits who ventured through its rings. Each of our cartels financed expeditions in search of it (and to establish proprietary claim), sending many across the vast In-Between to seek the Arbiter, one of the Eternal Ones said to dwell within the very core of the machine of Death. While each venture expanded our network, it failed to achieve its main goal. Oribos would seemingly remain out of reach until the whim of an Au navigator finally revealed the destination we had sought all along. The truth of whether that whim was premeditation or miscalculation is a tale they've yet to part with, but regardless, it resulted in Oribos being discovered at long last.

THE ETERNAL CITY

As newcomers to this wondrous city, it was quickly observed that the symbol of the coiled serpent prevalent across Oribos was of the same design we had noted in other locations in our travels. This recurring symbol of the FIRST ONES—which our scholars believe to be a representation of their infinite cycle—serves as a reminder that the destiny of Death is found across endless realms, as well as the worlds of the mortal plane.

Oribos was crafted by these First Ones to serve as the arrival point for mortal souls newly crossed over into the Shadowlands, where they were to be judged and placed into their fitting afterlife by the Arbiter. Some souls are to be rewarded for their benevolence in life with an eternity of calm and peace. Others are bound to punishments, unable to escape the consequences of their insidious actions before their arrival. Though it should be noted there are also credible accounts of mortal souls that have been observed to travel across the infinite realms once their hard-earned redemption was complete.

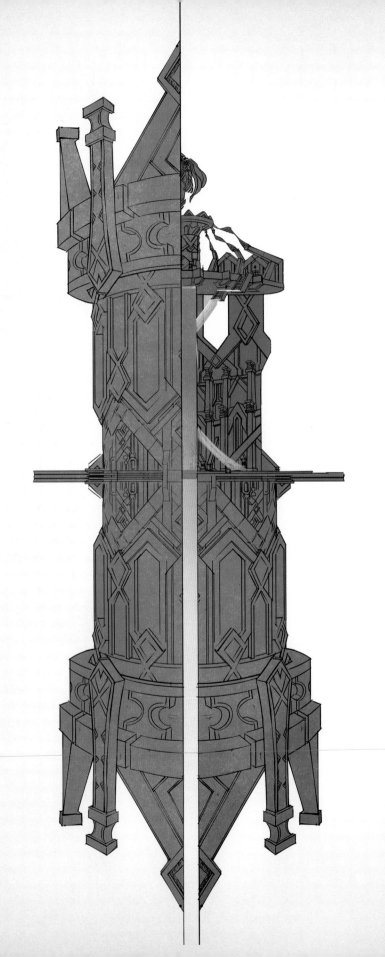

THE ARBITER

The Arbiter's origins are as shrouded in mystery as those of her fellow Eternal Ones who rule the realms of Death. Even a cursory investigation of the venerable architecture and detail present in the Eternal City would lead one to conclude that the Arbiter's station must have been established long before the first mortal soul arrived to receive her judgment. It was the wisdom of the First Ones, who believed the Arbiter best suited to this task among their children (using the quaint mortal shorthand for "progeny"). She was shaped by their hands and blessings for this critical role. And yet some among the ATTENDANTS of the Arbiter continue to insist that it was her choice to dwell within the heart of Oribos. Confirmation of either theory is yet to be proven, and unless she can recover from the event that caused her dormancy, it is possible we may never ascertain the truth of it.

To efficiently facilitate the assignment of the never-ending torrent of souls to their intended afterlives, the First Ones bestowed upon the Arbiter the ability to witness the entire breadth of the life of each soul. She would use this gift to great effect in the eons after. The attendants insist that their Arbiter has always been fair, impartial, and implacable. Yet in my research, I discovered certain ancient references to a time when this being was not quite so benevolent. But so worn and fragile were these records that I fear I cannot, in good faith, avow their veracity.

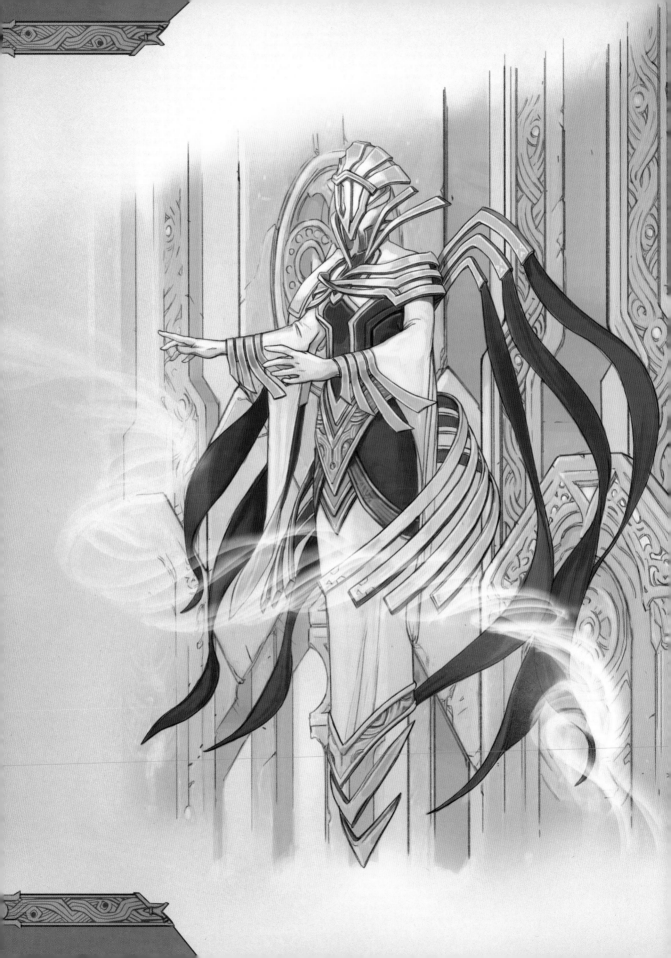

And as I have been repeatedly denied an audience with the Arbiter to seek answers from her unmoving visage, I fear I have no recourse but to accept the attendants' account for the nonce.

However, a nagging suspicion vexes me. The attendants of the Arbiter keep strict documentation of her judgments, but they share nothing on the story of why the First Ones let the crux of such a key function of Death's very framework rest upon a single entity. What was it about her that evoked such trust? While I may question the wisdom of a lack of redundant measures, I do not doubt the impressiveness of their creation, for the machine of Death worked flawlessly for uncounted ages. That is, until a singular event broke a system designed to be unbreakable.

The Purpose? Everything around you happens through the Purpose. The Purpose is the guiding principle of all the Arbiter's attendants. Just as Oribos is the heart of the Shadowlands, so the Purpose keeps the realms of Death in balance. The Purpose guides us. It shows us the path. All beings in the endless cycle serve the Purpose—even those who do so unknowingly or unwillingly.

Attendants

The attendants of Oribos are as much a part of the Eternal City as the Arbiter they dutifully serve. These individuals believe they were created by the Arbiter to tend to the needs of the Eternal City, thus enabling her to perform her countless judgments free of interruption.

Every decision that guides these attendants follows tHE PURPOSE. It is their belief that the infinite realms of the Shadowlands follow a grand pattern laid out by the creators of their Arbiter. Each attendant was designed to fulfill their part of the Purpose within their intended path and station—each mirroring a facet of the Arbiter's ancient form. From her hands and mind, to her visions, and even to her Honored Voice, TAL-INARA. Because the Arbiter never uttered a single word aloud, it was this notable attendant who was given the honor of speaking on her behalf. Following the event that caused the Eternal One to cease her judgments, it was Tal-Inara who insisted that their vaunted Purpose was the reason for the unprecedented arrival of living beings within the realms of Death. And it should once again be noted for the record that these same living beings from the world of Azeroth were the very ones who had escaped the Jailer's clutches in the Maw.

Of the functional roles served by the attendants, the first path is that of the caretakers. These Hands of the Arbiter have been entrusted with maintaining the functions and stability of the Eternal City. They are the most populous group among the attendants in Oribos, perhaps because the Arbiter's condition necessitates that the ongoing operation of the city falls under their jurisdiction.

The second path followed by the attendants is of particular interest to our cartel, as it belongs to their scholars. Within these beings resides the true history of Oribos, their knowledge bolstered by meticulous records of the innumerable activities that have occurred within the city's walls. Some of the most notable attendants serve within this path, including the Honored Voice mentioned earlier, whose duty was to interpret the will of the Arbiter and convey her wisdom to her people. Of equal interest is Fatescribe ROH-TAHL—known as the Vision of the Arbiter—whose insights into the threads of fate and the innumerable possibilities of the attendants' intractable Purpose are as ominous as they are powerful. It is said that the Fatescribe has the power to affect the destinies of living mortals; if true, the repercussions of such manipulation certainly merit intense scrutiny.

The third and final path of the attendants is that of the protectors, ever ready to defend their Eternal City from any force that might threaten it. From the rank-and-file guards to the Shield of the Arbiter—the highest station of their specific calling—all are formidable in stature and encased in impenetrable plate armor. These attendants number few in comparison to their counterparts, comprising what might be judged to be no more than a small militia force. And yet their scant numbers are also likely an indicator of the considerable power contained within each of them. As of this writing, I have not tested that theory, nor do I intend to.

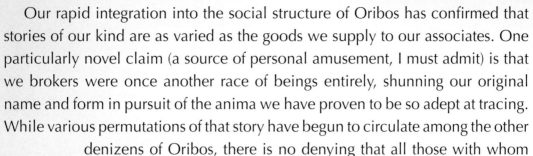

Our rapid integration into the social structure of Oribos has confirmed that stories of our kind are as varied as the goods we supply to our associates. One particularly novel claim (a source of personal amusement, I must admit) is that we brokers were once another race of beings entirely, shunning our original name and form in pursuit of the anima we have proven to be so adept at tracing. While various permutations of that story have begun to circulate among the other denizens of Oribos, there is no denying that all those with whom we transact consider us a savvy and adaptable people. No matter the request, our cartels continue to precisely tailor themselves to meet the various needs of our clients. To an eager customer, who we are is unimportant compared to what we can provide—which is exactly how the most profitable business is conducted.

We may be many things to our many partners, but one truth is undeniable. A broker is always armed with an uncanny ability to acquire elusive merchandise and services for those in need—if the price proves agreeable.

With our transaction completed, I request that you tell no one of the particulars of our arrangement. There are few things more distasteful to my kind than a patron incapable of discretion.

POINTS OF INTEREST
WITHIN ORIBOS

The brokers are not of Oribos. They are congenial and willing to aid you. Usually for a price.

The brokers' arrival in Oribos may have been a relatively recent event in its long history, but the Ring of Fates (where our cartel leverages its numerous skill sets) was perfectly suited for our every business need. Perhaps the First Ones in their infinite wisdom had anticipated our eventual arrival in the city. Thanks to that ancient foresight, Oribos has no lack of commerce. What you require is always within reach with the help of our cartels. We always find a way.

While many other halls exist within the Eternal City, it is with begrudging acknowledgment that the Hall of Shapes operated by the Au cartel appears to have the most continual traffic to its storefronts. Within their hall, beings from countless realms continue to find the resources they require to ply their unique trades. Regardless of the vocation of the being who visits the hall, the Au cartel would seem to have the endless supply and boundless motivation to secure a mutually beneficial transaction for their patrons.

Though the common crafter may come to rely upon the Au for mundane wares, it is well known among discerning buyers within the Eternal City that the Ta is where one seeks the uncommon and the peculiar. The truly auspicious customer is sure to satisfy their most elusive desires within our Hall of Curiosities amid wonders they could not discover anywhere else in Oribos.

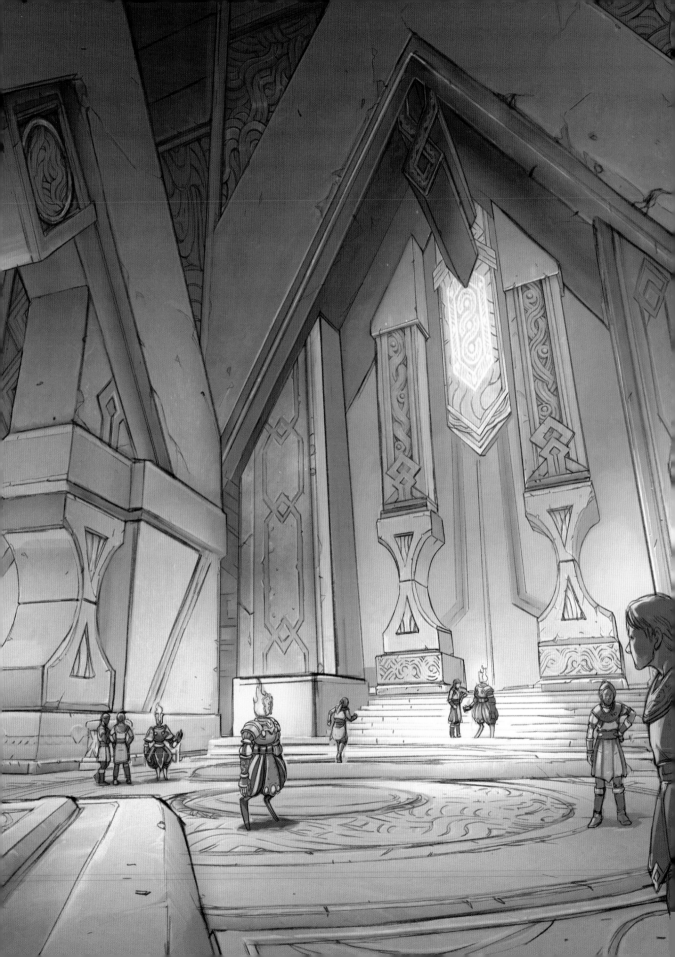

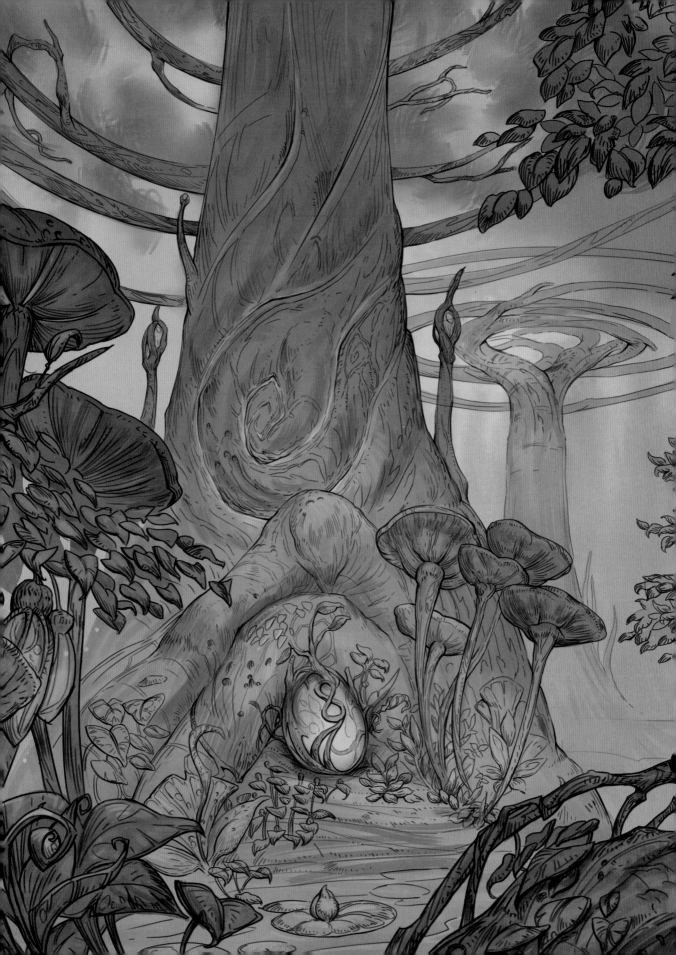

CHAPTER 4
ARDENWEALD

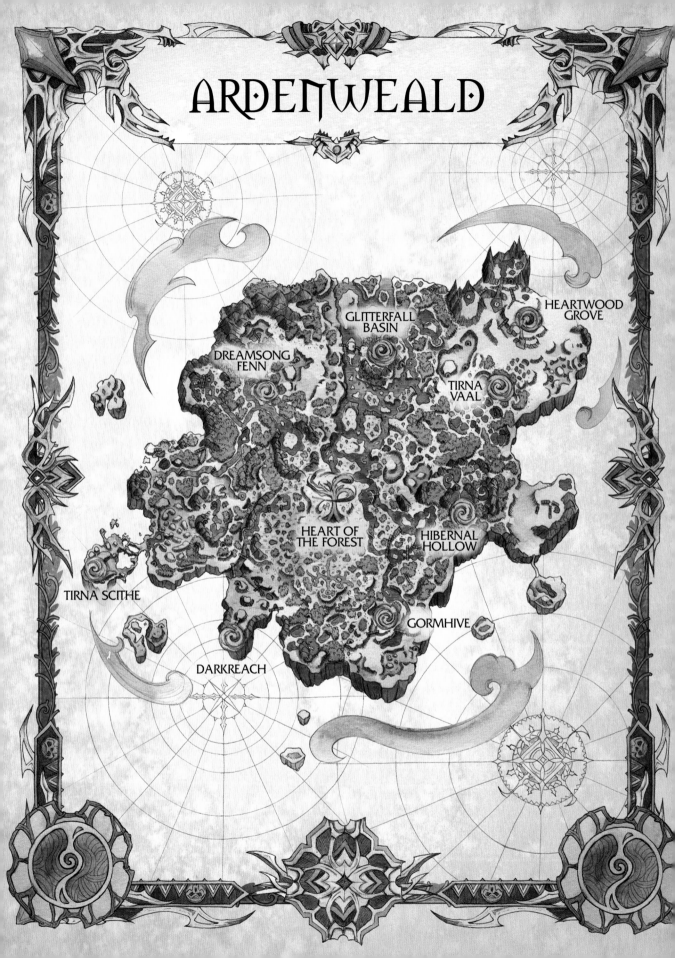

ARDENWEALD

DREAMSONG
FENN

GLITTERFALL
BASIN

HEARTWOOD
GROVE

TIRNA
VAAL

HEART OF
THE FOREST

HIBERNAL
HOLLOW

TIRNA SCITHE

GORMHIVE

DARKREACH

The seemingly endless forests of Ardenweald were designed to fulfill a vital function in the precarious balance between Death and Life: to embrace what Life could no longer sustain and foster it in Death, so that it can return to fulfill its place in the cycle anew. The framework of the cosmos shaped by the wondrous First Ones enabled their agents of Life to create vibrant realms that reflected seasons of that force in its apex, whereas its partner in Death would be their mirror.

FOREST FOR THE WEARY

Ardenweald is the afterlife for great spirits aligned with nature, which we've confirmed are often referred to by the souls in the moral realm as WILD GODS, AUGUST CELESTIALS, or even LOA. The terms appear to be interchangeable, given the number of sources investigated. Should an unfortunate fate befall their physical forms, these great spirits are drawn to Ardenweald to regenerate within wildseeds fed by anima. Once strength and spirit have been restored over the time needed to do so, they are returned to their plane of origin.

The immense celestial trees that anchor Ardenweald's many groves serve as both communities for its inhabitants and the primary means of anima distribution across the entire land. Night fae, the native denizens of the forest, remain devoted to their duties to Ardenweald and the part their realm plays in the great natural cycle . . . and also in their suspicion of outsiders, like myself.

Despite their prominence, the great loa and Wild Gods are not the sole residents of this realm. Ardenweald was also intended to be home to mortal souls who fostered a deep connection to nature and the preservation of its balance during their lifetimes. On the countless worlds they once inhabited, souls who served the wilds tend to fall within a certain set of vocations, referred to in the Azerothian languages by such names as druid, hunter, and shaman. The mortal souls judged worthy of such an afterlife are rewarded with the offer to continue their service to nature in Ardenweald. They are granted a curious boon to bolster their charge of the forests, entrusted by the Winter Queen and her Court of Night with the ability to change the very shape of their soul into an animal form of their choosing.

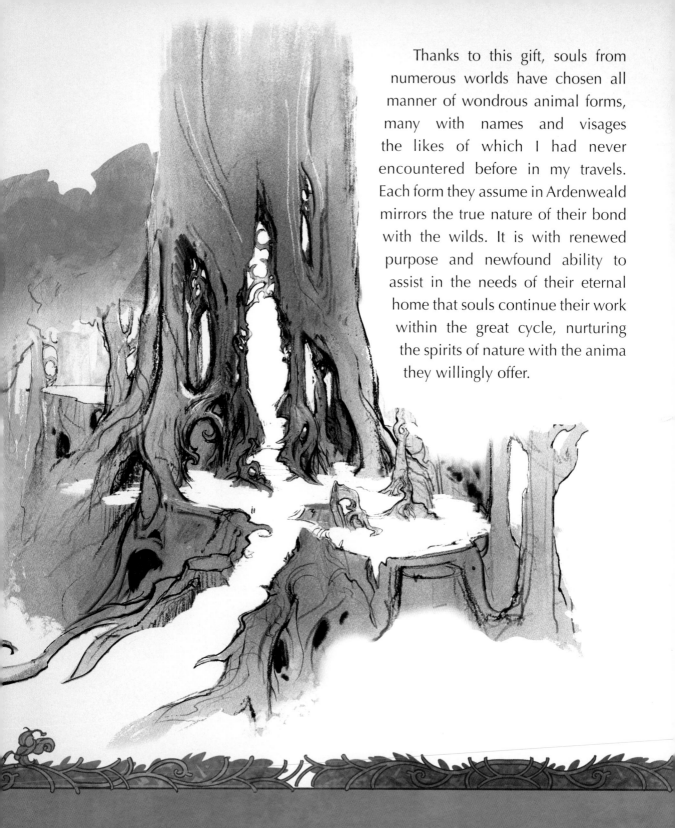

Thanks to this gift, souls from numerous worlds have chosen all manner of wondrous animal forms, many with names and visages the likes of which I had never encountered before in my travels. Each form they assume in Ardenweald mirrors the true nature of their bond with the wilds. It is with renewed purpose and newfound ability to assist in the needs of their eternal home that souls continue their work within the great cycle, nurturing the spirits of nature with the anima they willingly offer.

I grant you this boon. Become as the wild creatures are.
Whatever shape speaks to your soul, it shall be yours.

WILD GODS, LOA, AND THE EMERALD DREAM

In the course of my research, it became apparent that many of the Wild Gods, loa, and nature spirits who have rested in Ardenweald manifest in physical form as ferocious avatars of natural forces who are often worshipped as deities within the mortal plane. After pondering this observation, it became clear to me that this was no coincidence or accident, and in fact it speaks to a larger purpose served by such entities. During their time in mortality, these beings are tasked with the protection and cultivation of living worlds, especially ones of particular interest such as Azeroth. Many of the Wild Gods bound to this unique world are also bound to a place they refer to as the Emerald Dream, a realm of Life that can only be truly perceived (and thereby navigated) by those attuned to nature, such as the aforementioned druids. Souls who have visited this realm describe it as a land teeming with creatures of Life, where both time and distance are mutable: a never-ending primordial woodland that would seem to be the very counterpart to Ardenweald.

Of note among the natural deities is a Wild God named CENARIUS. According to the night fae, it is common for Wild Gods to assume the forms of native animals. And yet the visage of Cenarius is largely humanoid, closer in appearance to the mortal souls of his chosen world. No offer of collateral would result in additional details on this matter; it was simply not information the fae were willing to barter. The only hint I was given originated from the preferential treatment he receives from the ruler of Ardenweald.

The leader of the night fae, the beloved Winter Queen has shown considerable favor toward Cenarius on those occasions when his spirit dwells in Ardenweald; his rest and recuperation within her eternal forest was described not unlike the attention one of us brokers would provide a member of our own cartel—or as the mortals say, a "family."

In addition to the Wild Gods, equal interest should be paid to a race seemingly unique to Azeroth that also bears a connection to the aforementioned Emerald Dream. Known colloquially by Azerothian souls as "green dragons," these beings are depicted as winged, emerald-scaled serpents with the innate ability to manipulate natural energies and navigate the Emerald Dream as effortlessly as they glide through the air of their native world.

Ysera

Ysera speaks of Korialstrasz, whom I loved dearly . . . but I loved none more than her. She gave me a gift when we first became Aspects. Take it with you and save your friend. And, champion . . . please tell my sister that she is sorely missed, fondly remembered, and deeply loved.

Once more the recurring importance of Azeroth echoes in this grimoire, for I have learned that one of these green dragons had developed such a strong connection to the great cycle that its soul was drawn to Ardenweald upon the conclusion of its mortal life. According to the marginally helpful fae (and in between their numerous distractions), the soul of this great dragon, a leader of her scaled kind known as YSERA, was nearly lost entirely as the anima drought decimated the realm. According to one faerie's enthusiastically theatrical retelling, Ysera's soul would have faded from existence were it not for the concerted efforts of the Maw Walkers and the night fae, as well as the direct intervention of the Winter Queen. Ysera's salvation came at a dire cost for both the green dragon and the Eternal One. For the Winter Queen, a sacrifice of her own essence—her very being—was required to save Ysera's soul from oblivion. This bears repeating: the Winter Queen gave a portion of her own existence to save this Ysera—not merely some resource that could one day be replenished, but a personal measure from her own finite well. It underscores again how important those born of the world of Azeroth truly are. And for Ysera, the price was that this child of Azeroth was now bound forevermore to Ardenweald, and she would therefore share in whatever fate might yet befall its twilight forests. Whether she will ever be free to depart its tranquil boughs remains unclear to me—and to her as well, it seems.

THE WINTER QUEEN

Ardenweald's function supports our theories that the First Ones crafted the underlying framework for the cosmic forces of our universe: one that would facilitate an endless cycle of Death and Life, which they made central in their creation. The role that they designed for the Winter Queen within this cycle was a vital one, requiring a bond between the conflicting forces so intimate that it is logical to assume that the existence of a reciprocal being who serves as her counterpart can be found as well.

The night fae of this realm seem unable or unwilling to provide details that might substantiate my theory, though I did locate one source who, when pressed, admitted to having overheard the Winter Queen refer to a certain Life-bound entity as her sister, a familial term that would seem ill fitting when used in reference to a being who is directly contrary to her very nature. Yet just as the Winter Queen assumed her place in the Pantheon of Death, this apparent counterpart took up a similar position in what we must hypothesize to be a PANTHEON OF LIFE.

Whatever relationship might have existed between the two "siblings" whose bond was fundamental to the eternal cycle between Death and Life seems to have been all but severed. For how could even two figures of such unimaginable power commune across the veritable chasm that separates their disparate planes of existence? It is said (only in hushed whispers, I assure you) that in the eons that followed their parting, signs of resentment and pain began to mar the placid visage of the Winter Queen, especially when she heard the name of her sister uttered within her forest. Even her recent action to save Ysera betrays those emotions, for I am told that the Winter Queen seemed to show a moment of hesitation before making the sacrifice required to save the soul of the dragon so dear to the one she resented. Yet it must be said that the truth of these matters exists solely within the Winter Queen herself, and to ask the inscrutable Eternal One for answers would be a fool's errand indeed.

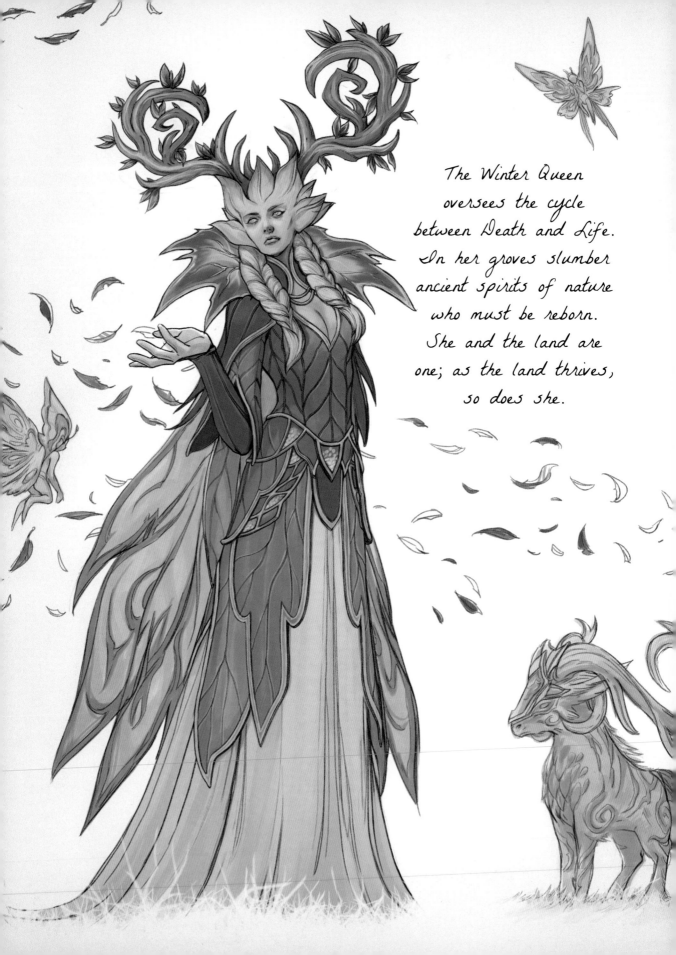

The Winter Queen
oversees the cycle
between Death and Life.
In her groves slumber
ancient spirits of nature
who must be reborn.
She and the land are
one; as the land thrives,
so does she.

THE DENIZENS
OF ARDENWEALD

The **NIGHT FAE** of Ardenweald are the native denizens of the eternal forest tasked with the cultivation of the realm and all those who dwell within. Each type of fae differs from the other, yet they all operate in harmony with others, regardless of their calling. Some of these fae specialize in the tending and caregiving needed to nurture dormant nature spirits, whereas others support the well-being of the fae themselves. Others are entrusted with the protection of the forest entire.

Among these forest defenders, one group stands above the rest. It is a fearsome force to behold—a host of night fae known as the Wild Hunt. The various fae who comprise the Wild Hunt, from the modest faeries to the towering tirnenn, answer the call of the Winter Queen in times of desperate need. The summoning from their queen heralds a congregation of the finest huntresses and hunters the entirety of Ardenweald has to offer. Why this group does not remain as a standing army seemed odd, as assembly of the Wild Hunt is a rarity in the history of the eternal forest. Perhaps calling them forth levies a sort of taxation upon each grove of the realm, depriving them of caretakers, stewards, and protectors—all of which are not promised to return. With the anima drought and the uncertainty abounding in Ardenweald, its Wild Hunt stands ready to defend the forest at any cost. Yet fae and mortal souls alike pray for peace to be restored to their beloved forest, and they long for the day when the merciless assembly of the Wild Hunt shall be needed no longer.

Because the Winter Queen's attention is frequently spread across the vast expanse of her forest, governance of the night fae is overseen by a council of faefolk known as the Court of Night. These officials attend to the needs and entreaties of their peers and are duly authorized to speak on behalf of their queen, regardless of where she may be at that precise moment. Those who have spoken with me in her stead are cited below for reference's sake, including their self-proclaimed titles (which I consider to be of dubious legitimacy):

 DROMAN KRELNOR—a vorkai, now lost to Drust invaders

 LORD RENARD—a Wild God (of an unknown world), "Student of Silence"

 LADY MOONBERRY—a faerie, "Lover of Narration"

 DROMAN ALIOTHE—a Wild God (of an unknown world), "Hero of the Hollow"

 DROMAN TASHMUR—a tirnenn, "Kin to Trees"

It is said that the first fae to have emerged from the twilight forest are beings called tirnenn. Their station as firstborn among the fae is likely why their appearance is so akin to the very trees of Ardenweald. These inscrutable creatures can alter the forests at will to address the shifting needs of its many inhabitants. These elder fae are enigmas even to the other denizens of Ardenweald.

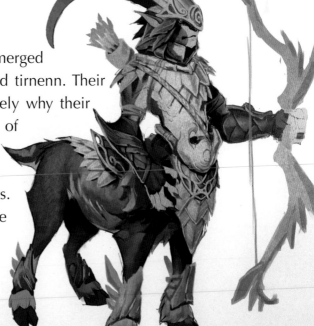

The tirnenn claim that Tirna Achiad was the very first tree the Winter Queen cultivated in Ardenweald. This tree became known as the Heart of the Forest: the site where the Court of Night convenes to discuss matters pertaining to the groves and their inhabitants. Though I would delight to behold its beauty firsthand, the Wild Hunt ensures that only its members are permitted within . . . and they have a knack for seeing through my illusionary guises.

The fae known as SYLVAR function as the crafters and tenders of the afterlife's forests. Ardenweald's version of our own Au cartel, in a sense. In all interactions they have proven to be harmonious and graceful, traits that seemingly extend to the very products they fashion. Their crafts are ever aimed to maintain the ebb and flow of existence in Ardenweald and possess what our living mortal customers refer to as a "rustic" aesthetic. I took the liberty of arranging shipments of such goods to be offered for sale by our cartel in Oribos—for a judicious cut of the profits to reward my proactivity, of course.

The demeanor of the fae known as VORKAI is quite literally the inverse of their sylvar kin. They are fierce protectors of Ardenweald who aggressively keep their borders clear of any perceived danger—including inquisitive types like myself. The dedication these fae have to their calling as guardians of Ardenweald is tenacious, to say the least.

Of all the night fae who dwell in Ardenweald, I find the FAERIES the most vexing. These fae are among the smallest in the forest, winged beings who are nearly as skilled as a broker in the art of illusion. While they revel in trickery, I am told that their intended purpose is to soothe great resting spirits within the groves with song and mirth.

Try as I might to endure their tedious performances, I find little of value beyond confirming their penchant for deception.

Having catalogued the native denizens of the forest, it seems prudent to discuss the role and purpose of the night fae covenant. As this tome has already established, each of the five primary afterlives is overseen by a member of Death's pantheon and carries out a crucial function within the Shadowlands. Yet powerful as these figures are, the Eternal Ones alone could not perform the myriad duties necessary to ensure the stability of their realms. Thus, four covenants were founded to serve as vessels of the pantheon's will—the Maw preferring to torment its souls than work profitably with them. While the form and makeup of each covenant may differ between the afterlives of their origins, the underlying structure for each appears quite similar. At its core, a covenant is a group of dedicated individuals who have vowed to carry out their sacred duties and see to the needs of their unique environment. Pertinent to our cartel's interests, the important truth is that wherever a covenant can be found, profitable secrets assuredly lie in wait.

When the Winter Queen stretched out her hand and created Ardenweald, the tirnenn were among the first to grow. They dug their roots deep and lifted walls high. They shaped the groves.

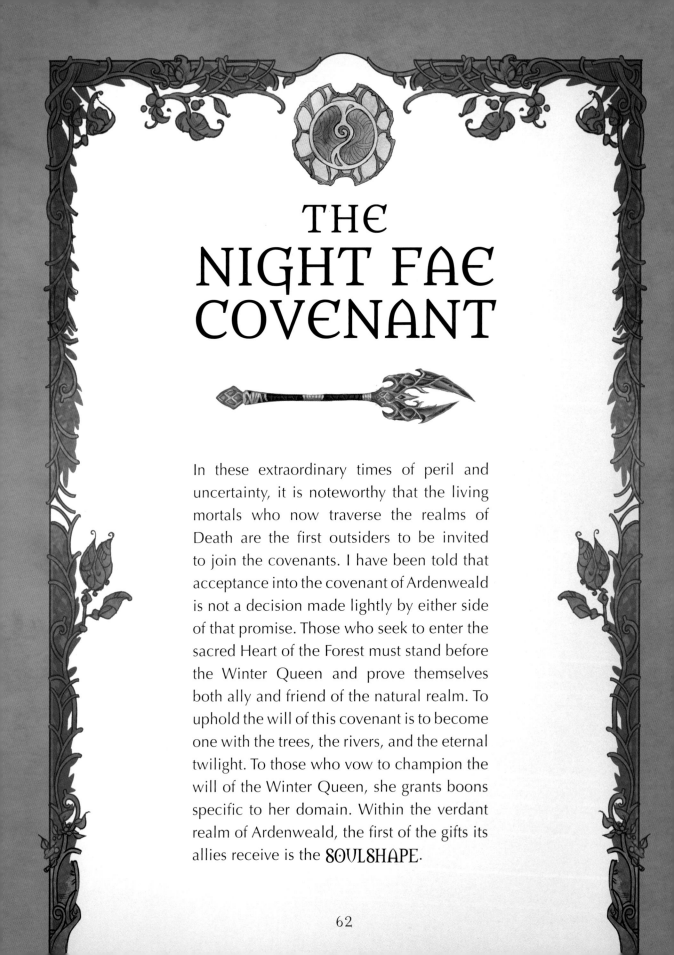

THE NIGHT FAE COVENANT

In these extraordinary times of peril and uncertainty, it is noteworthy that the living mortals who now traverse the realms of Death are the first outsiders to be invited to join the covenants. I have been told that acceptance into the covenant of Ardenweald is not a decision made lightly by either side of that promise. Those who seek to enter the sacred Heart of the Forest must stand before the Winter Queen and prove themselves both ally and friend of the natural realm. To uphold the will of this covenant is to become one with the trees, the rivers, and the eternal twilight. To those who vow to champion the will of the Winter Queen, she grants boons specific to her domain. Within the verdant realm of Ardenweald, the first of the gifts its allies receive is the SOULSHAPE.

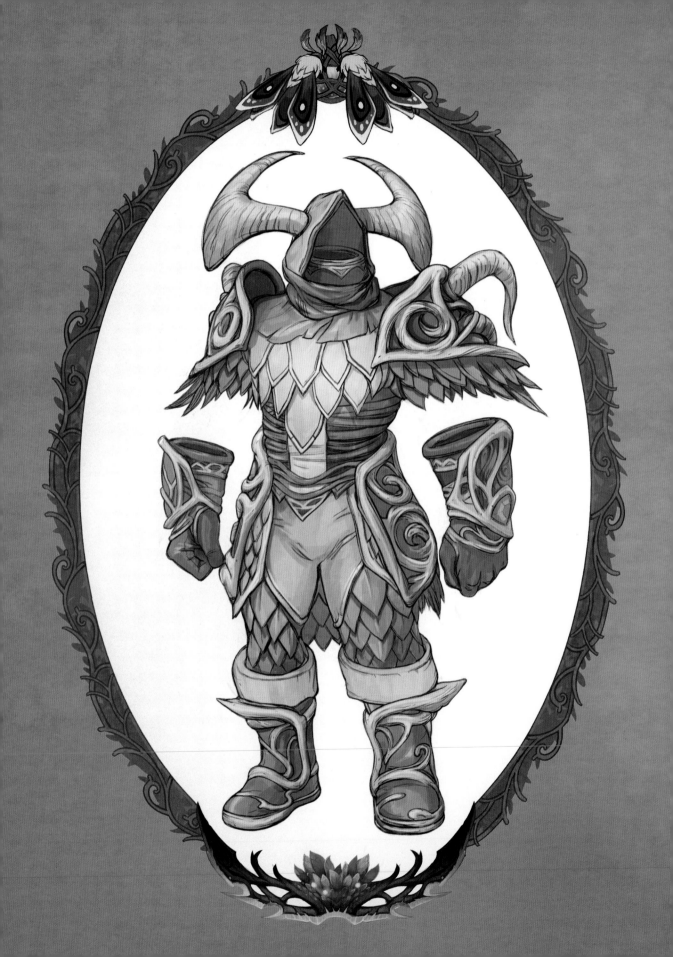

In the earliest accounts of the eternal forest, when Tirna Achiad and the night fae were yet young, the first mortal soul arrived and stood before the Winter Queen. She looked upon them with her tranquil eyes and saw that though their destination had been determined by the Arbiter, the desire to serve the wilds was their own. The queen welcomed the soul and tasked them to tend to the spirits and aid in their renewal. The soul was unsure how to accomplish such a task without a body to aid them, and so the Winter Queen granted them the ability to take the form of any creature of the wilds. Thus the boon of soulshape was given to the first mortal soul in Ardenweald and would thereafter be bestowed upon all those who enter into the covenant of the night fae.

Yet another gift the night fae share solely with their most ardent champions is a suit of armor sourced from materials of the eternal forest itself. Crafted by gifted sylvar and tailored to the specific vocation of their champion, the natural armor of Ardenweald is a wondrous sight—and surely represents an untapped business potential. If the sylvar can be convinced to produce quantities sufficient for our cartel's needs, one can only imagine the profits we will reap in the markets of Tazavesh!

An interesting commonality to note across each of the covenants was first found here in my journey to Ardenweald. Another gift the Court of Night bestows upon its covenant members is the gift of soul bonds. As one soul binds themselves to a

willing night fae, so too does the night fae bind themselves to their companion. Though I have been prevented from personally witnessing the ritual itself, I have verified that this binding of souls forges both of them into something greater than before. Souls have admitted that within their bond, their hopes, fears, dreams, and even their very memories become intertwined with the bondmate.

They share a strength in pursuance of their common goals. While such a complete violation of privacy would be abhorrent to any broker, the process is one that our Azerothian interests have partaken in quite willingly. Thus, despite my distaste with the very notion, the potential benefits behoove us to investigate further into the nature of this union.

An item of exceeding interest to our efforts is held by a night fae covenant member known as WATCHER VESPERBLOOM. This vexing faerie is what passes for an information broker in Ardenweald. The task of keeping the Hunt informed of any nefarious developments falls to this Vesperbloom, archiving countless unspoken truths within a simple tome with an equally simple title: the Book of Secrets. The item came to my attention as its pages were connected to a Maw Walker's search for a countercurse that could save a spirit. Aside from the valuable knowledge that we could glean related to the Winter Queen's edicts and movements of the Wild Hunt, an item of such interest to a Maw Walker could provide insight into their thought process and relationship with Ardenweald itself.

BASTION

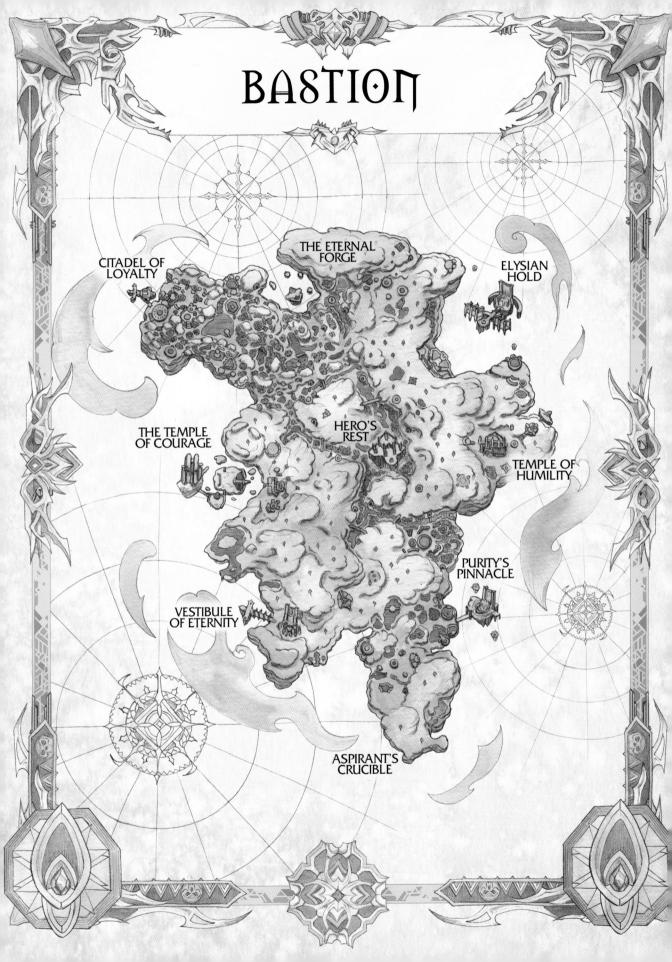

CITADEL OF
LOYALTY

THE ETERNAL
FORGE

ELYSIAN
HOLD

THE TEMPLE
OF COURAGE

HERO'S
REST

TEMPLE OF
HUMILITY

PURITY'S
PINNACLE

VESTIBULE
OF ETERNITY

ASPIRANT'S
CRUCIBLE

Bastion is a beatific land within the realms of Death. It is a place wholly dedicated to mortal souls who made service and duty their true vocation in life (such as the paladins of Azeroth and the Light-Bearers of Fanlin'Deskor). This idyllic afterlife serves a critical role in the machinery of our infinite afterlives: to carry the souls of the dead from their worlds into the Shadowlands. And yet all those deemed worthy to tread upon its golden fields soon face a veritable eternity of trials ahead. Their arrival in Bastion is merely the first step upon a path that many here have affirmed takes eons to travel—the kyrian path of ascension. Their rituals have remained unchanged throughout the long history of this realm's existence— at least, until the anima drought and the breaking of the Arbiter plunged the Shadowlands into turmoil. But before I delve further into those events and their influence upon this realm and its inhabitants, let us examine Bastion's intended purpose.

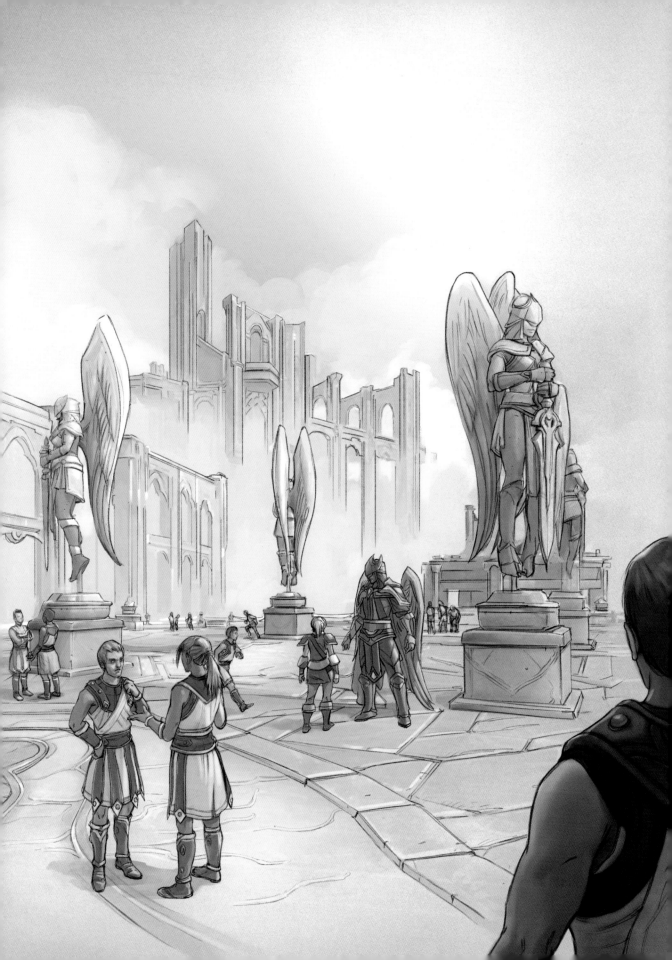

THE KYRIAN

No matter from which of the innumerable worlds a mortal soul hails, those who are sent to Bastion are granted a new form: that of the KYRIAN. The newly arrived soul is welcomed by other kyrian and their automated constructs alike and given ample opportunity to adjust to the newfound knowledge that the span of their mortal existence has truly ended. It seems this kindness is preparation before the chosen must shed themselves of their mortal trappings to properly follow the vaunted path of ascension. To help the mortal soul in the transition from Life, the exasperatingly helpful stewards, those remarkably sturdy and abysmally cheerful avian natives, provide creature comforts for souls who may feel overwhelmed by the process.

Now steeled to face the rituals that lie ahead, the mortal soul—referred to as an ASPIRANT thereafter—begins to focus on shedding the attachments and desires they held in life, all to be catalogued within the archives of Bastion. As we see with many realms of the Shadowlands, mortal souls are ever burdened by decisions that were made during decisive moments in mortality. I am told that only by completely surrendering such burdens can an aspirant rise above them to prove worthy of ascension. For the adherents of the path, a kyrian must embrace their sacred duty with impartiality and selflessness, which necessitates forfeiting their past life and challenging memories. The process of this intentional forgetting is varied, yet for each soul it is a considerable undertaking. Many aspirants even combat physical embodiments of the tormented thoughts and emotions that are being expelled from their consciousness.

THE PATH OF ASCENSION

Countless trials are placed before the kyrian aspirants, some of which take eons of intense training and repetition to complete. Aspirants who conquer every test they are pitted against are brought to the Crest of Ascension to be honored for their service. In a glorious ceremony overseen by the Archon, the subject is granted the gleaming wings for which the kyrian are known. While the newly ascended kyrian revels in their achievement, ascension is merely the first step of an even greater calling that will be soon asked of them.

As the First Ones wrought the framework of the cosmos, no doubt they understood that a constant and reliable stream of mortal souls crossing the veil would be necessary for sustaining the burgeoning system of Death. In order to ensure the stability of this process, denizens of the Shadowlands would be required to bear witness to the final moments of mortal life and then ferry the souls to the Shadowlands once their corporeal existence had ended.

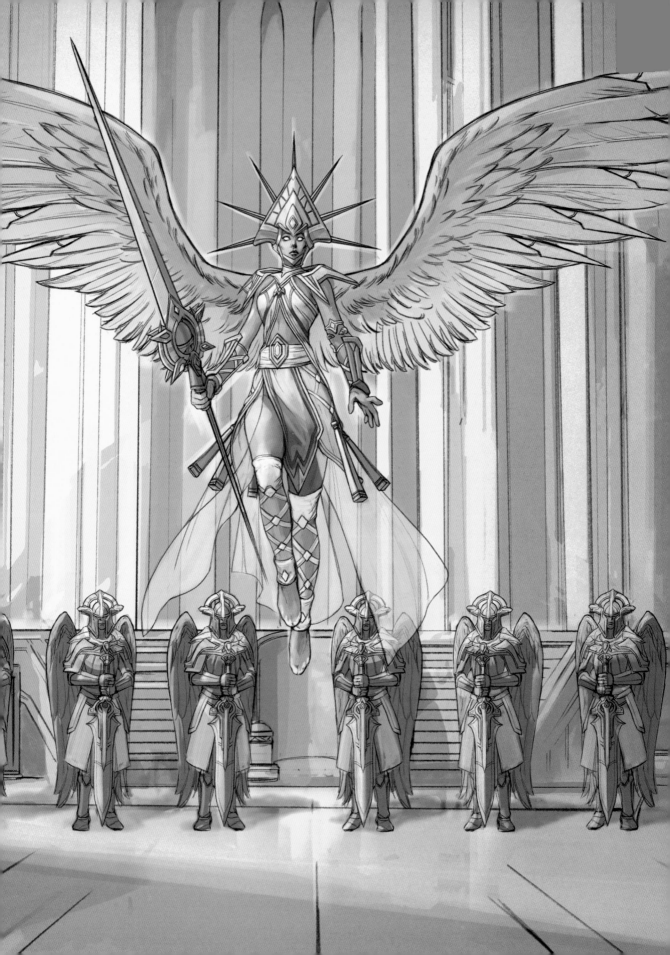

THE ARCHON
AND THE PARAGONS

The Progenitors must have known that oversight of this pivotal process would require an indomitable spirit with an unwavering adherence to duty and service to these mortal souls. The Archon of Bastion, a statuesque being known as KYRESTIA THE FIRSTBORNE, would embody that spirit. She established the path that all kyrian were to follow, never allowing her people to stray from her singular focus on the purpose of Bastion.

The virtues of the Archon upon which she forged the kyrian path are mirrored in her trusted lieutenants, the Paragons. Their archives cite that these ascended kyrian have served for so long, and with such distinction, that they were elevated to become the embodiment of these qualities and oversee temples dedicated to their ideals. Aspirants who walk the path of service will toil under the tutelage of the following Paragons:

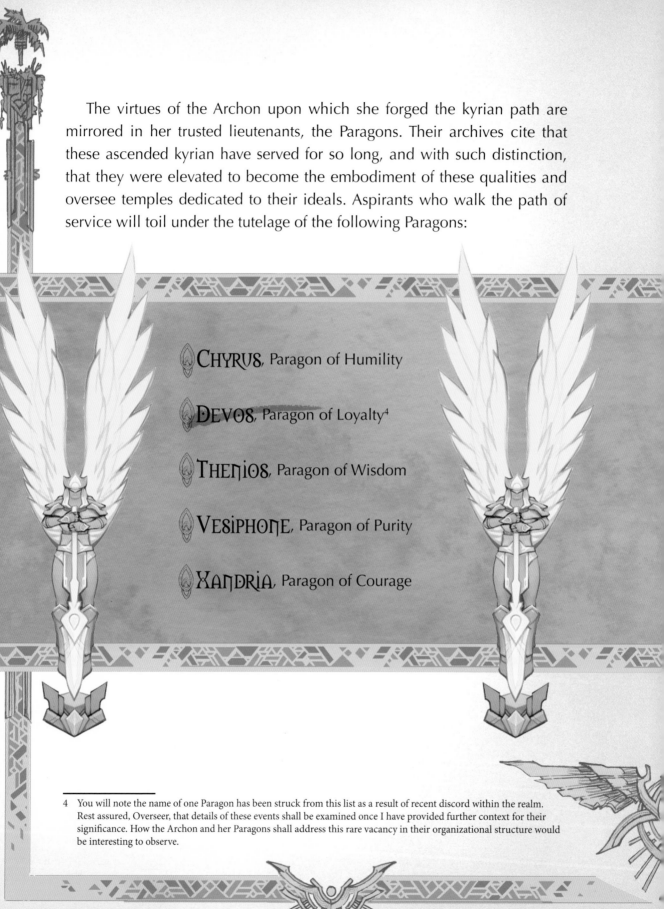

CHYRUS, Paragon of Humility

DEVOS, Paragon of Loyalty[4]

THENIOS, Paragon of Wisdom

VESIPHONE, Paragon of Purity

XANDRIA, Paragon of Courage

4 You will note the name of one Paragon has been struck from this list as a result of recent discord within the realm. Rest assured, Overseer, that details of these events shall be examined once I have provided further context for their significance. How the Archon and her Paragons shall address this rare vacancy in their organizational structure would be interesting to observe.

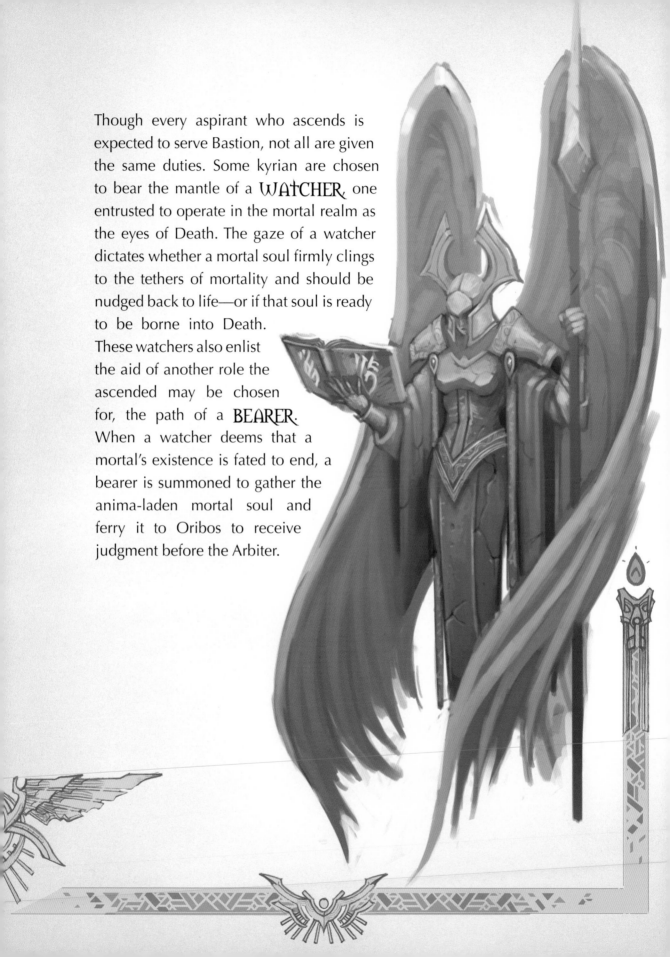

Though every aspirant who ascends is expected to serve Bastion, not all are given the same duties. Some kyrian are chosen to bear the mantle of a WATCHER, one entrusted to operate in the mortal realm as the eyes of Death. The gaze of a watcher dictates whether a mortal soul firmly clings to the tethers of mortality and should be nudged back to life—or if that soul is ready to be borne into Death. These watchers also enlist the aid of another role the ascended may be chosen for, the path of a BEARER. When a watcher deems that a mortal's existence is fated to end, a bearer is summoned to gather the anima-laden mortal soul and ferry it to Oribos to receive judgment before the Arbiter.

The Forsworn

In the wake of the anima drought and the lack of new souls arriving in Bastion, fear and doubt spread like a plague through the aspirants—and even into the ranks of the ascended. These darkened kyrian joined together as the Forsworn, and their presence has torn a great schism in the ranks of the kyrian between the adherents to the path and those who forsake it to "save" Bastion from what they see as a flawed system. The Forsworn believe that the Archon's edict to shed their mortal memories is unjust, a crime that has robbed them of their individuality—a point that even I admittedly find convincing. And so did the Archon's own Paragon of Loyalty, Devos.

Though I was not personally privy to the events that led to Devos's rise and fall, the account that follows is based on details I gleaned from the living mortals who forged a covenant with Bastion. It seems the Paragon's darkening resulted from her interactions with an Azerothian named Uther the Lightbringer.

Though mortal souls have always arrived in the kyrian realm intact, Devos discovered that Uther's life had been ended by a weapon of the Maw, leaving his soul wounded and perhaps not entirely intact. When Devos brought this matter before the Archon, the Paragon was forcefully reminded that the eternal charge of the kyrian does not include questioning the Arbiter's judgment. Estranged from the path she had served so loyally, Devos conscripted Uther to her cause and secretly gave her oath to the Banished One. Though it appears not all Forsworn realized their rebellion was serving the Jailer, he nonetheless benefitted from the chaos and disharmony that infected the realm—including an attack on the Temple of Courage by the necrolords of Maldraxxus, made possible due to the sabotage of Bastion's defenses by the Forsworn.

Ultimately, the Forsworn assault on the Spires of Ascension ended in defeat. Devos and the darkened kyrian who followed her fell at the hands of Azerothian champions. Yet it seems their philosophies may be taking root in Bastion. After striking down Devos, it is said the Archon openly admitted that there may be value in kyrian retaining the memories from their mortal lives. If true, such a shift in perspective may provide opportunities our cartel can use to our advantage.

For eons, we have been told to "purify" ourselves. To let go of our memories, our identities, our loved ones. All in the name of service. But what do we serve? An impotent Arbiter, an oppressive law! Our sacrifices were made for nothing!

As established earlier, being declared worthy of ascension in Bastion is a hard-won honor. Never meant to be freely given, it was the foremost goal set before all souls who walk the path of aspirant. To the kyrian, the very arrival of such souls meant that the Arbiter's infallible judgment deemed them suitable for Bastion—and for the sacrifices that each of them would be expected to make.

And yet, tucked away within the archives to which I have been afforded access, I have found rare cases of aspirants who failed to ascend, whether through an inability to part with memories of their previous lives or by somehow falling short of the Archon's rigorous standards. These aspirants were unable to overcome the challenges that line the path to ascension, despite their countless attempts and the unwavering support offered by their fellow kyrian along the path. The visage of these struggling aspirants was said to change, shifting from their bright azure skin to a darkened version of themselves that reflected the inescapable turmoil felt within. It is worth noting that early citations of these darkened kyrian were so infrequent in the eons of Bastion's history that fellow ascended had attended to them with ease. Those who struggled were offered guidance and after purification from these doubts would return to the path and regain their luminosity. And yet as I dug deeper into the archives, I found mention of aspirants deemed beyond hope of resuming their eternity of service. Such rare unfortunates were exiled from the golden reaches of Bastion to be placed once more before the Arbiter and sent on to another afterlife.

Such a banishment may, in times past, have been considered something of a kindness. But given the current state of Oribos—where the devastated Arbiter delivers all into the Maw—it is a fate bereft of mercy. It is now clear that those outcasts have, whether willingly or through coercion, sworn an oath to the Jailer's cause. The living mortals of Azeroth who escaped the Maw informed me that it was these very Mawsworn kyrian who crossed over into their world and abducted several of Azeroth's leaders.

STEWARDS

Of course, while I have spoken at length on the kyrian, it should be noted that they are not the sole denizens of Bastion. Alongside them stand the **STEWARDS**, stout and tenacious avian beings born from the magics of Death to assist the kyrian in their duties. The stewards are entrusted with a range of roles, from simple groundskeeping to even the complex care and maintenance of the mechanical marvels of Bastion, such as their goliaths and the colossi automatons. Where the goliaths serve as unyielding bulwarks for the kyrian and ensure order is maintained, the colossi are their last line of defense, activated only as necessity dictates. Ultimately, the stewards' numerous automatons are empowered with anima to serve a dual purpose: the first is to train aspirants in combat, and second is to serve as the defenders of Bastion.

Of all the irrepressibly helpful stewards, peerless among them in intellect and speech is a legend by the name of **MIKANIKOS**. This renowned steward is known as the Forgelite Prime—unparalleled in his skills at building and maintaining kyrian automatons. On my visits to the realm, I endeavored to enlist his expertise to craft certain devices for the benefit of our cartel; unfortunately, Mikanikos rebuffed my exceedingly generous offer and muttered something about needing to find his particular tools. Annoyingly dutiful, just like the rest of his kind!

Of interesting note is that stewards have a tendency to keep mementos of their small achievements within Bastion—curios to remind them should they forget any notable accomplishments. Odd that Bastion itself seems built to enforce forgetfulness, and yet those charged with its upkeep seek to circumvent it. A potential opportunity for us brokers to exploit, indeed.

THE
KYRIAN
COVENANT

As mentioned earlier in this treatise, I have recently been afforded the opportunity to speak to living mortals who pledged themselves to the kyrian, and after earning their trust, they have told me a great many particulars concerning their covenant. This order convenes at the beacon of Bastion's light known as the Elysian Hold. This grand holdfast rests in the shadow of the Spires of Ascension, home to the seat of Kyrestia the Firstborne, the Archon. Unfortunately, only those who have achieved ascension—or who otherwise aligned themselves fully with the kyrian covenant—are permitted to set foot within its hallowed halls. A pity, as the Maw Walkers tantalize me with tales of the wealth of information kept within the Elysian Hold that would be of incalculable value to our cartel.

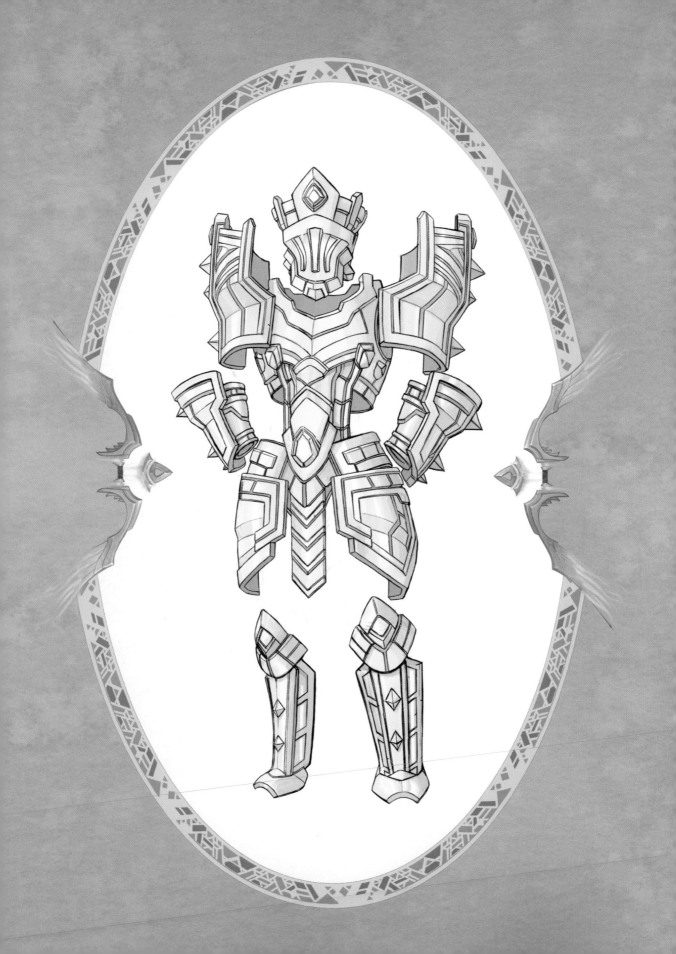

For the living mortals who joined the kyrian covenant, one of their first undertakings proved particularly crucial to Bastion's survival. The sacred artifact known as the Crest of Ascension—where aspirants who passed their trials were awarded their kind's highest honor—was destroyed in a Forsworn attack. Without the Crest to create new ascended, the very future of the kyrian way of life hung in the balance. The monumental task of its reconstruction could only be entrusted to the greatest minds and champions of Bastion, necessitating both the supreme skills of the Forgelite Prime and the tenacious courage of the living mortals of Azeroth. While the Forgelite Prime and his forgehands began the extensive effort to create the device anew, it fell to the Maw Walkers to discover a means to empower the new Crest of Ascension once assembled.

The mortals scoured the realms of Death to locate potent objects to empower the Crest, which I am told included a vessel of Ardenweald, a symbol of contrition from Revendreth, and even the heart of a Maldraxxi margrave. The Crest was completed, and new ascended are once again filling Bastion's endless skies.

The Crest of Ascension is symbolic to both the kyrian and to our cartel. For the kyrian, its re-creation enabled it to become stronger than it was before. For the Ta, it serves as additional evidence that the involvement of Azerothians is instrumental in the continued longevity and survival of the covenants in which they serve, and it may prove useful to our own efforts to uncover the secrets of the shapers of the Shadowlands.

As with all other covenants that exist in the Shadowlands, entering into a pact of kinship with the kyrian is not a choice made on mere whim. Those who join the cause of Bastion vow to place the greater good ahead of self-satisfaction.

In recognition of such selfless service, the kyrian grant those in their covenant the provision of their own steward. These endlessly energetic helpers perform all sorts of menial tasks for their assigned kyrian allies, including providing an apparently endless supply of an elixir in which our cartel would no doubt find value: a so-called "Phial of Serenity." This alchemical draught is said to have both restorative and purifying properties contained within a single vial. My offers to franchise the curative compound outside of the borders of Bastion have proven unsuccessful, but I remain hopeful that I can secure a sample that, in the hands of our alchemists, might be duplicated and sold at a substantial markup.

As in the covenant of the night fae, the ritual of soulbinding is also practiced by the members of the kyrian covenant. Achieved through a reportedly ancient device—the features of which bear clear resemblance to artifacts attributed to the First Ones—soulbinding forges a bond between a pair of willing kyrian that is sacred, solemn, and priceless. It is a process that allows for no deception between bondmates once all is laid bare to the other. While such an unguarded connection seems appealing to those who partake, it once more goes without saying that this abhorrent procedure would be disastrous to our business dealings.

The defensive protections afforded to those blessed by the talented artisans of Bastion are truly remarkable indeed. Each piece of their armor is specifically crafted for its intended champion. While the individual segments can be appraised separately as works of art by even the most inexperienced broker, it is when all pieces are joined that art becomes masterpiece. As the kyrian and the guardians of Bastion protect their realm, so too does the armor imbue its wearer with the very strength of the realm. It behooves us to develop inroads and investigate further opportunities to learn kyrian forging techniques, lest our rivals in the Au cartel secure such secrets for themselves.

Pelagos is my soulbind. He is my brother, my closest friend, my mentor, and my student. He knows me completely, and I him. It is a bond stronger than any other.

CHAPTER 6

REVENDRETH

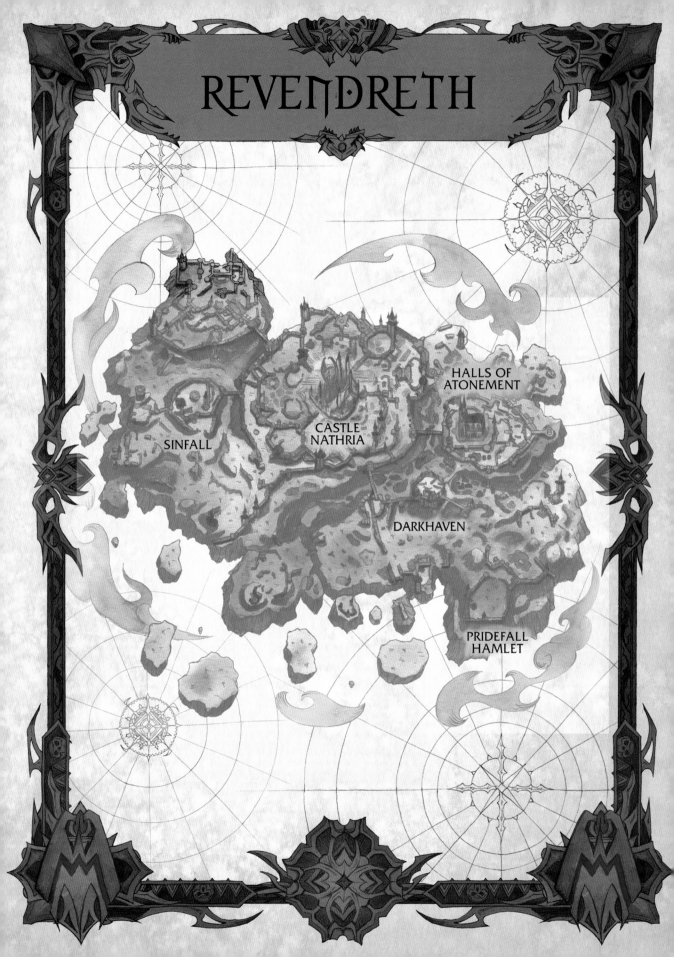

REVENDRETH

SINFALL

CASTLE
NATHRIA

HALLS OF
ATONEMENT

DARKHAVEN

PRIDEFALL
HAMLET

While all the realms of Death have suffered under the vengeful eye of the Jailer, none bears the scars of his malevolence more acutely than Revendreth. Though its leader, Sire Denathrius, was trusted by his fellow Eternal Ones to oversee the redemption of the prideful souls placed into his care, it is plain that Denathrius betrayed his calling. Revendreth's former master sided with the Banished One, unleashing a torrent of precious stockpiled anima into the hungering Maw. Were it not for the living mortals who fought beside the venthyr rebels, Denathrius might still be acting in service to the Jailer's cause.

But I digress. Before examining the particulars of Revendreth's current state, it behooves us to consider the realm as it once was, throughout the countless eons in which it fulfilled the noble purpose bestowed upon it by the First Ones.

WHERE PENANCE IS PAID

Of all the realms of Death to which I've traveled, I can fully attest that no afterlife demands more of the mortal souls entrusted to its care than Revendreth. Indeed, from its clouded crimson skies to the dark stone ramparts of CASTLE NATHRIA, Revendreth imposes its stern will upon all who tread its cobbled streets. It is not timid souls who are sent to this afterlife, but rather those who are fraught with pride and arrogance, or renowned for great acts of wrath, desire, avarice, and envy.

It is understandable for one to look upon Revendreth as a place of punishment. Yet in truth, the Arbiter saw within these souls the promise of redemption. Rather than consigning them outright to the inescapable darkness of the Maw, these troubled souls were to be given one final chance to achieve something greater.

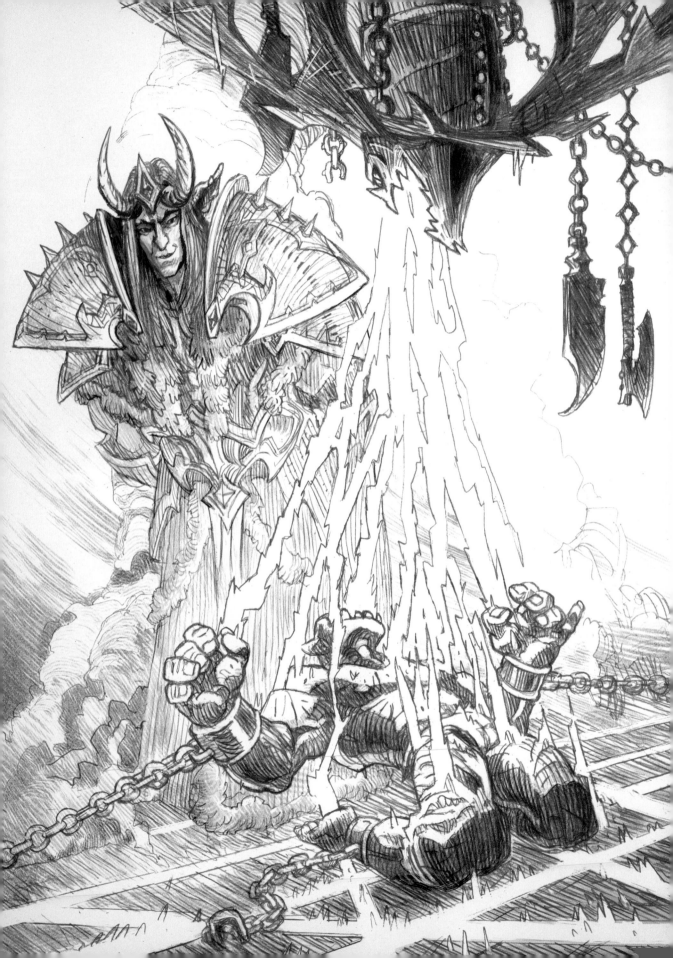

SIRE DENATHRIUS
AND THE VENTHYR

In life, I committed unspeakable horrors in the name of justice. For my crimes, I was sentenced to this place. It was only after eons of suffering and penance that the master saw me fit enough to join the ranks of the venthyr. Now I serve as tormenter and teacher so that those like me may yet find redemption.

This calling is overseen by the sharp-fanged VENTHYR who inhabit Revendreth's plentiful gothic hamlets, wards, and districts. Formed long ago in the image of their Sire, the venthyr oversee the long process of stripping away the arrogance of defiant mortal souls. These rituals have a secondary benefit—the more prideful the soul, the more abundant its supply of anima. And while every afterlife draws upon the anima of the souls consigned to it, no denizens of the Shadowlands excel at harvesting this precious resource more than the venthyr.

It is perhaps this extraction expertise, perfected over endless ages, that makes the treachery of Sire Denathrius all the more tragic. For the anima that was intended to sustain the workings of this afterlife was instead hoarded away in vast storehouses beneath the opulent halls of Castle Nathria.

There, sycophantic nobles danced and gorged themselves (along with willing accomplices of the Xy cartel, I would add) while the common folk were left to suffer as the realm crumbled away beneath their feet.

Those of us who traverse the afterlives recall a time not so long ago when the very firmament of the Shadowlands was rich with anima, thanks to the endless bounty of mortal souls flowing into the realms of Death. When the Arbiter ceased her judgment and the souls instead funneled into the Maw, a drought set in, and the anima that had once seemed to be of infinite supply all but dissipated. We learned too late that this was no coincidence; as the breaking of the Arbiter threw the realms into confusion and panic, Sire Denathrius employed the very spires of Revendreth to siphon the ambient anima and add it to his hidden stores. All the while, the drought's devious architect claimed to be just another victim of its tragedy.

While some loyal to the old regime continue to vie for personal power in the wake of Denathrius's downfall, the venthyr are nonetheless making strides to restore order and recommit themselves to the duty owed to the souls in their care. Prince Renathal, who served as the Sire's right hand until he rose up in defiance of his lord's wickedness, is spearheading efforts to ensure that Revendreth sees—to borrow a mortal expression—brighter days ahead. [5]

5 Please note that, as of this writing, there are no plans to actually alter the sky's luminance. Mortal metaphors, while evocative, are often confusing.

THE HARVESTERS AND THEIR WARDS

The vast realm of Revendreth is divided into seven distinct wards, which were long ago placed under the jurisdiction of a select group of venthyr referred to as the Court of Harvesters. Every one of these notable individuals was chosen by Sire Denathrius to serve as an instrument of his authority. To ensure their loyalty and obedience, each Harvester was given a most exquisite medallion that granted a modicum of Denathrius's power while binding the wearer to his will.

When the treachery of Denathrius was revealed, conflict arose between those Harvesters who remained loyal to the Sire and others who worked to overthrow him. The ensuing tumult has resulted in a new Court of Harvesters being established in the ancient keep known as Sinfall, all of whom are committed to sharing their authority for the good of the realm. Its members and their wards include:

- **PRINCE RENATHAL**, Harvester of Dominion (Ember Ward)

- **THE ACCUSER**, Harvester of Pride (Ceremony Ward)

- **THE COUNTESS**, Harvester of Desire (Castle Ward)

- **THE CURATOR**, Harvester of Avarice (Catacombs Ward)

- **THE STONEWRIGHT**, Harvester of Wrath (Military Ward)

- **THE FEARSTALKER**, Harvester of Dread (Forest Ward)

- **THE TITHELORD**, Harvester of Envy (Village Ward)

Two former Harvesters—tHE FEARStALKER and tHE TitHELORD— refused to disavow their allegiance to the Sire and have been struck down for their defiance. As of now, their positions remain vacant.

In a move that is uncharacteristically egalitarian of the venthyr, all members of the new Court of Harvesters (save one) have surrendered their medallions of power for the good of Revendreth. This effort is led by PRINCE RENATHAL, said to be the first venthyr shaped by Denathrius's own hand. Somehow this charismatic figure survived his exile into the dark reaches of the Jailer's stronghold and has proven capable of winning many of the notoriously selfish Harvesters to his cause. The Stonewright is the lone exception, though she does so not out of malevolence. Her reasoning is to retain a measure of independence for herself and the stoneborn forces who serve her in Dominance Keep, her citadel in the Military Ward.

Though the sturdy battlements of Sinfall attest to the fact that Revendreth is well fortified, it is clear that the First Ones never intended for this place of atonement to serve as the front lines of conflict against those forces that exist beyond the realms of Death. Curious, then, that the land bears the mark of one such incursion. In a district still smoldering after millennia—referred to by the venthyr as the Ember Ward— invaders from the realms of Light inflicted a searing scar upon its landscape. The motivations for this attack were long the subject of hushed whispers among venthyr nobility, who speculated whether it was an unprompted act of aggression on the part of the Light or in retaliation for some perceived slight by Sire Denathrius.

This broker would speculate on the latter, as after the underground catacombs of the Sanguine Depths were exposed, living Maw Walkers rescued a naaru named Z'RALI who had been imprisoned within. Though liberated, this naaru has chosen to remain in Revendreth and stand guard over the sentient blade Remornia, once wielded by Denathrius himself. I have heard living mortals speaking of their victory over the Sire, and they claim that the weapon now holds his very essence within it. I would prefer to confirm this rumor for myself, but this Z'rali does not seem amenable to answering my questions.

The aptly named Forest Ward is a densely wooded hunting ground once ruled over by the Fearstalker, the Harvester of Dread. In the course of her brutally pragmatic "penitent hunt," her loyal venthyr would release captive souls into the wilds, only to chase them down and leach the pride from their prey. She believed that souls laden with dread would be taught a harsh lesson in humility, resulting in an increased anima harvest. Though she was never the most congenial of hosts, the Fearstalker did tolerate our cartel's presence in the discreet trading outpost we christened the Night Market. Thanks to our interactions with Revendreth's native denizens—as well as the Maw Walkers who brought us various objects of interest— Ta'lan and our other operatives in the Night Market have gleaned valuable information that we believe will soon bear fruit for our endeavors.

The Village Ward was looked after by the now-deposed Tithelord, the Harvester of Envy. It is a humble-looking hamlet full of downtrodden venthyr and their servants who aspire to be welcomed into the aristocratic society of the Castle Ward. Of course, to be left longing for something unobtainable can be a form of punishment in and of itself.

As for the Castle Ward, the venthyr who proudly dwell there stand among the most decadent—and dangerous—Revendreth has ever seen. It is governed by the Countess, the Harvester of Desire. A certain number of these genteel nobles remain loyal to Sire Denathrius and can prove quite hazardous when presented with uncomfortable questions . . . such as those pertaining to past deeds that they would prefer to keep secret.

The Countess has long been renowned for her skill in navigating courtly intrigue, and it is said that her extravagant galas have often served as a distracting setting to bring her rivals to heel.

The Ceremony Ward, as its name would suggest, is the district of Revendreth dedicated to the rituals of atonement that mortal souls fraught with sin must undertake. The Accuser, the Harvester of Pride, is so singularly well suited to this duty that Sire Denathrius sought to replace her with a sniveling loyalist who would be more amenable to serving his whims. Now restored to her position, the staunchly incorruptible Accuser pontificates from her pulpit within the Halls of Atonement. I fear our cartel is unlikely to be welcomed within her domain.

The Curator, the Harvester of Avarice, who oversees the Catacombs Ward, possesses an archival knowledge of the hidden pasts of all those who inhabit Revendreth. Imagine the value such information would have to our cartel! Thus far, the Curator has proven to be as implacable as the Accuser, so it seems that we brokers have quite the labor in store for us to uncover the secrets she holds. Yet even without her cooperation, we still have a means of investigating the pasts of notable venthyr via a curious artifact known as a sinstone.

Each of these sinstones represents a soul who
has come to this place and cleansed themselves of their
impurities, eventually moving on from Revendreth or
accepting the role of a venthyr.

Sinstones

Upon arrival in the village of Darkhaven, each and every mortal soul is compelled to inscribe all their transgressions committed in life upon their SINSTONE: a chiseled monument that serves as a tangible reminder of their wrongdoings. The soul then bears the sinstone through an arduous gauntlet of rituals designed to expose the failings of the individual and help them put their misdeeds behind them (and, as previously noted, to allow the venthyr to harvest the rich anima built up over the course of such a transgression-filled life). But should the mortal soul prove resistant to the venthyr's methods, there is no recourse but to expel the irredeemable soul into the Maw.

After ages of enduring the rigors of repentance and proving that their atonement is complete, the redeemed soul is offered a choice: leave this brooding realm behind to be judged worthy of a different afterlife by the Arbiter, or remain in Revendreth to become a venthyr and aid other souls on their paths of penance. For those who choose the latter course, the continued existence of their sinstones is a matter of perspective. Some look upon them as an enduring symbol of what they have personally overcome and welcome the chance for these monuments to inspire others. Yet many see sinstones as the most powerful and despised weapons in the entire realm, used by the ambitious to shame and manipulate their rivals. It is said that of all the cruelties Revendreth has to offer, the worst fate of all is to be faced with the very thing they labored for eons to escape.

We now name the sins of a soul that Revendreth shall forever
be responsible for the exsanguination and education of. Let these
names contextualize and manifest the turmoil they carry within.
For their salvation may we control these burdens, harvest these
burdens, and drain these burdens.

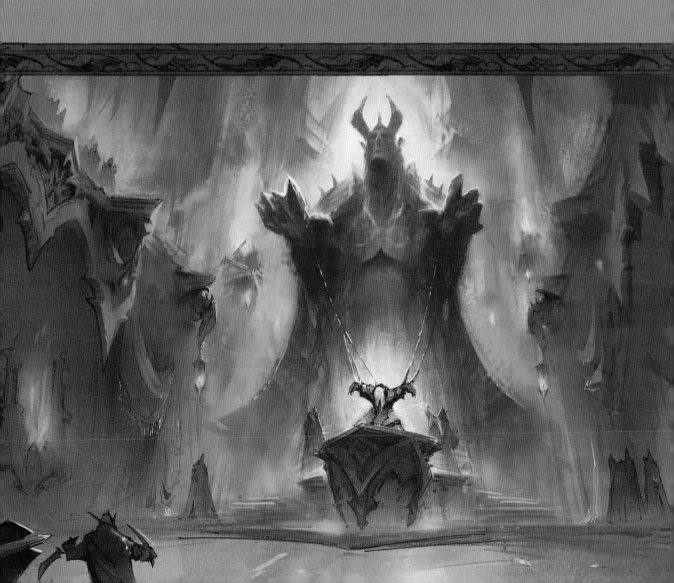

THE VENTHYR COVENANT

My investigation into the history of Revendreth has uncovered that the ruined tower of Sinfall wasn't always in its current state of disrepair. I have bartered for secrets which reveal it to be the very site where Denathrius first founded his original Court of Harvesters, and there are darker tales in which the Sire dabbled in forbidden rituals he sought to keep from the eyes of his fellow Eternal Ones.

Whenever it was that the Ember Ward was bombarded by the Light, the walls of Sinfall withstood the assault. It is believed this was due to the defenses Denathrius constructed to contain the powers he wove within. Far from the shadow of Castle Nathria, the ruined tower shields still-held secrets from the earliest days of the realm.

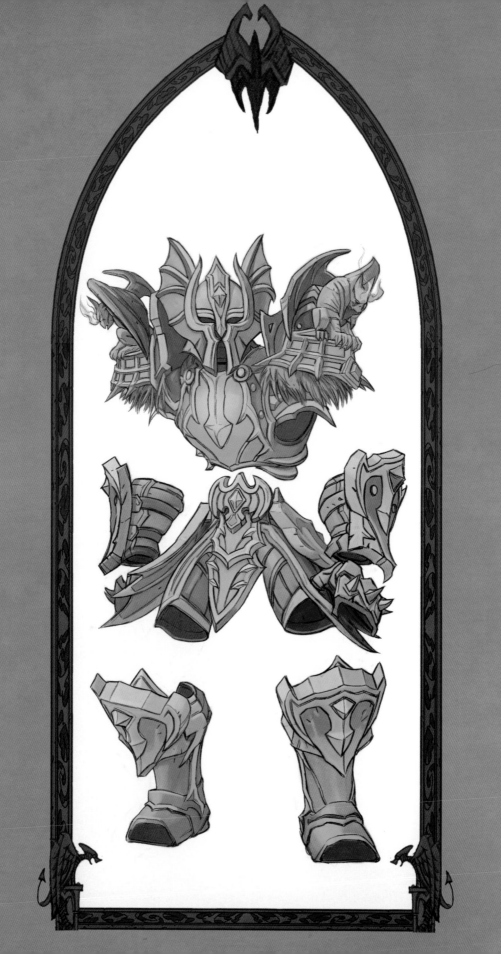

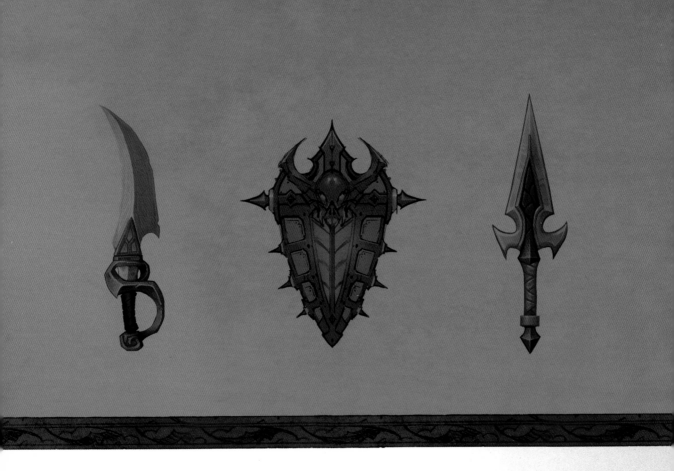

Prince Renathal and his fellow Harvesters have leveraged the durability of this ancient fortress to serve as the sanctum of the venthyr covenant. After exposing the deceit of the Sire, it seems a number of the living mortals who thwarted him have sided with the venthyr and now endeavor to restore Sinfall to greatness.

In a realm so fraught with secrets and deception, trust is perhaps its rarest, most precious commodity. Venthyr have certainly been slow to share knowledge with me and the brokers of the ΠIGHT MARKET, and it seems they are no less cautious when forming bonds among their own kind.

Imagine my surprise, then, to learn that not only have living Maw Walkers quickly come to be seen as allies, but they have even been welcomed to partake in the ritual of soulbinding! Because the very nature of the process lays bare the memories and ambitions of each participant, I daresay that there is no afterlife in which this ritual holds greater significance. Choosing the venthyr covenant is to be welcomed into an eternal family—one that values trust and loyalty and therefore does not look kindly upon those who forsake oaths made to their beloved kin.

One of the gifts that the venthyr bestow upon new oath-makers is a form of translocation magic: an art they have perfected called the Door of Shadows. Those entrusted with this power seem to slip away into the night itself and reappear at a destination of their choosing. A valuable gift indeed for one who must navigate a land of winding roads and shifting alliances.

Those living mortals who gain sufficient standing with the Court of Harvesters are rewarded with fineries befitting their service to Revendreth. The exquisitely detailed armor offered to defenders of the realm serves as a steadfast reminder of the bond shared between the venthyr and the heroes who helped liberate them from the treachery of Denathrius.

"I swear my loyalty to the venthyr."

"Your loyalty has never been questioned. Be sure you give us no cause to do so."

THE STONEBORN

Just as Sire Denathrius brought forth the first venthyr into his realm, so the venthyr carved their own numerous constructs from the very rocks of the land itself. The anima-infused stoneborn were made to serve in varied capacities—from keeping unruly souls on the path to atonement to acting as mighty soldiers charged with protecting their domain. Each and every one is instilled with an unwavering sense of loyalty to their makers.

The militant gargoyles of the **STONE LEGION** are a prime example of the stoneborn's potential, the most formidable of which were formed by the hands of the Stonewright, the Harvester of Wrath herself. These beings were chiseled from Revendreth's own quarries and were intended to be utterly incapable of betraying their duty—though it should be noted that just as the venthyr were divided between loyalty to Denathrius and the forces of Prince Renathal, so did the stoneborn take sides in the rebellion.

There are lesser forms of stone-wrought creations, such as the tiny, winged fiends who seem to delight in vexing honest travelers such as myself. And the hungry fangs of the vicious gargons—used so effectively in service of the Fearstalker's hunt—serve as looming reminders that straying from the path is perilous indeed.

Though not stoneborn per se, no accounting of the denizens of Revendreth would be complete without discussing the dredgers. "Out of sight and out of mind" are said to be the ideal traits of these muddle-minded servants. Tasked with menial labor—from sweeping floors to sacrificing themselves for venthyr entertainment—they crawl forth from primordial muck and are shown little respect by their superiors. Yet simple minds are easily manipulated, and I have found that a measure of feigned kindness toward one of these wretches can often result in them offering up secrets overheard from their dismissive masters.

It has long been speculated that the venthyr and the stoneborn were not the only beings Denathrius created over the countless ages of his reign. Rumors speak of mysterious entities sent to infiltrate the ranks of the Sire's enemies, from the shadowy domain of the Void Lords to the demonic armies of the Burning Legion. What form these beings took we cannot say for certain—yet.

The discovery of the entrapment of the naaru Z'rali, along with certain written evidence recovered within a long-abandoned spire of Sinfall, suggests that the existence of such creations by Sire Denathrius is no mere flight of fiction. These agents appear to be wholly adaptable to their surroundings, unseen guests who gain the trust of the very forces they have been sent to undermine. We must now ponder the terrifying possibility that these beings could have embedded themselves anywhere—even within our own cartels.

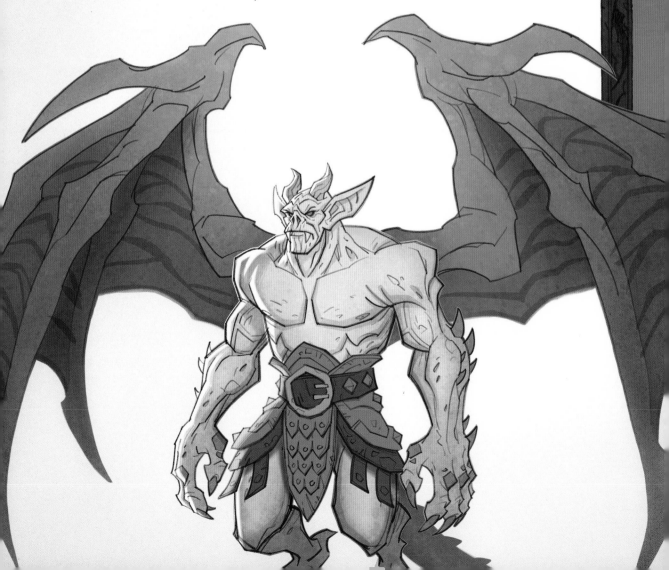

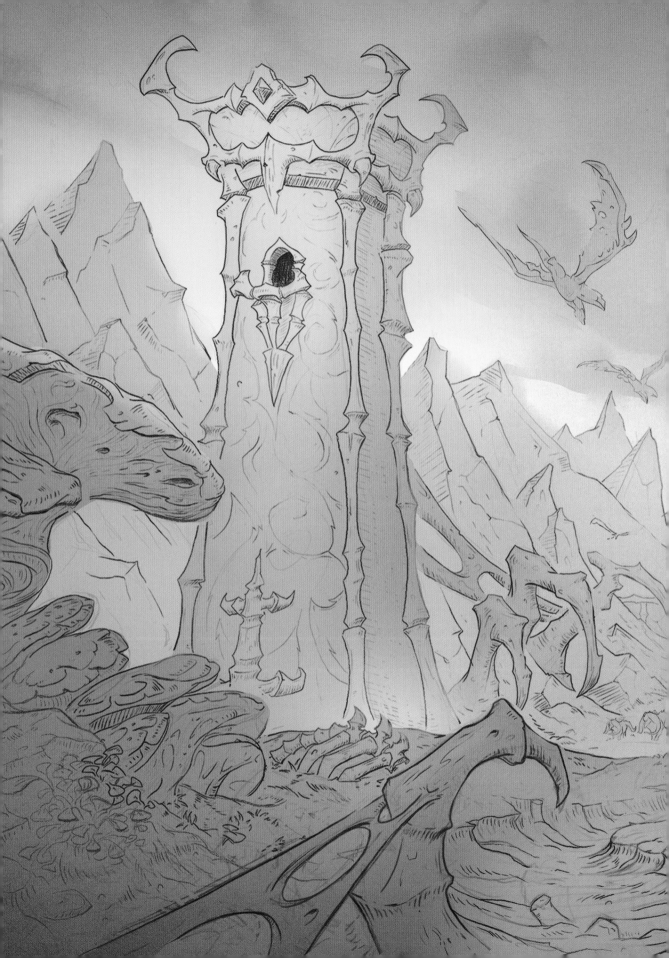

CHAPTER 7
MALDRAXXVS

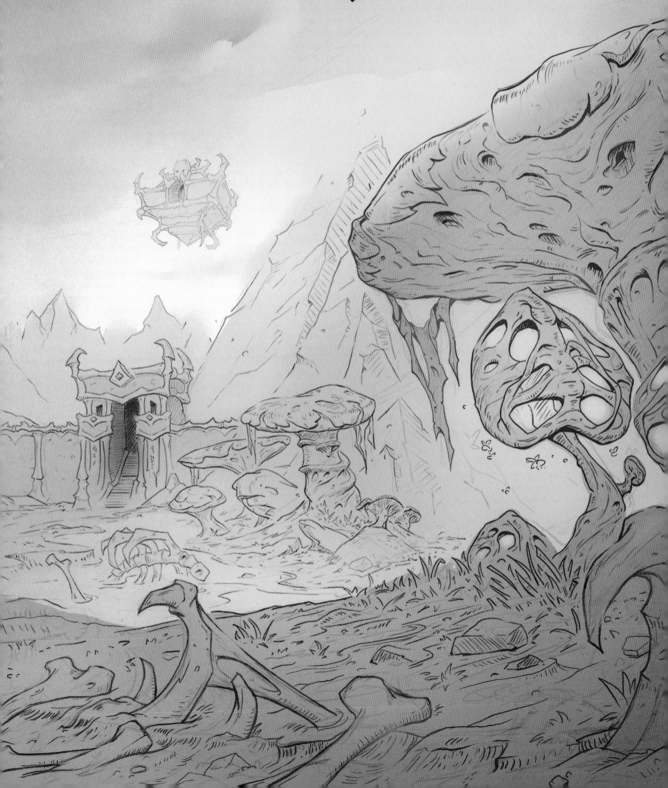

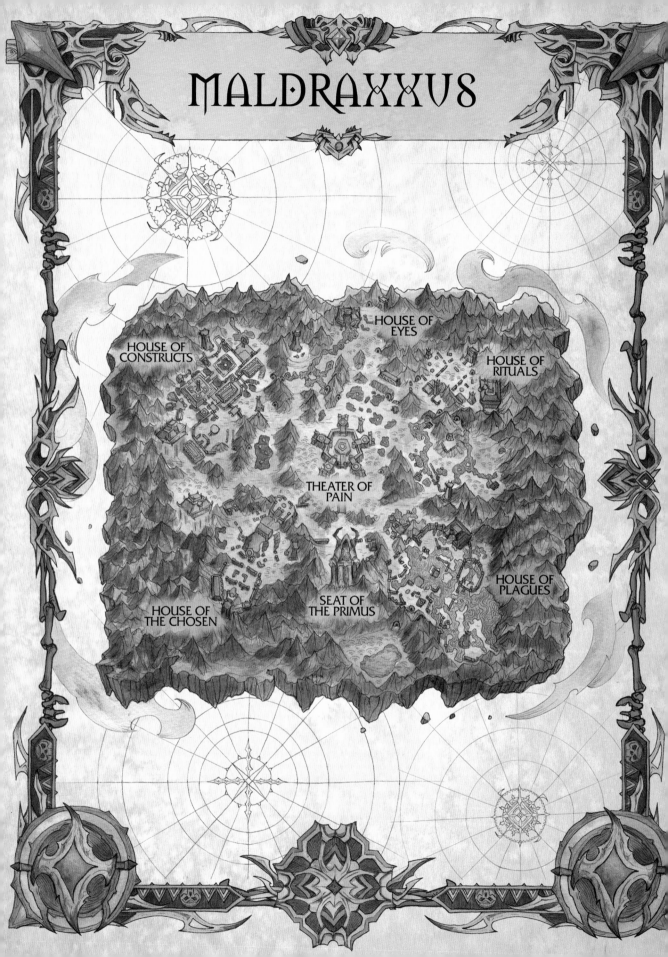

MALDRAXXUS

HOUSE OF
EYES

HOUSE OF
CONSTRUCTS

HOUSE OF
RITUALS

THEATER OF
PAIN

HOUSE OF
PLAGUES

HOUSE OF
THE CHOSEN

SEAT OF
THE PRIMUS

Maldraxxus is a realm of unending conflict: a place of sharpened bravery and brutality meant for the mighty, not the meek. Only souls who find purpose in its harsh horizons of bone spires, pestilent pools, and craggy mountains can call this afterlife their own. Those chosen for this fate must maintain the constitution necessary to stare unflinching into the grim visages of towering warriors, skeletal liches, and flesh-knitted abominations upon arrival to claim their place upon its ichor-saturated battlefields of constant contention.

The home of the immortal army of the Shadowlands is not solely a destination for the sadistic or the martial-minded. Those who dwell here by the grace of the Arbiter are sent as much for their courage and determination as for their ferocity. The ultimate qualification for a place among the Maldraxxi is victory—achieved either by honorable or questionable means, whether through might or through guile. I am told that any soul steeled to overcome adversity fulfills the purpose of Maldraxxus: to forge an immortal army of unyielding souls ready to defend Death from those forces that threaten its sanctity.

THE ARMY OF THE DEAD

When the will of the First Ones forged the Shadowlands, it is evident that they saw a need to protect the realms of Death from any outside influences that might threaten it. To not only match but to overpower all potential battlefronts ahead, they imbued the very landscape of Maldraxxus with qualities that are unique among the infinite afterlives. To train its legions to prepare for the myriad of threats they foresaw arising in the cosmos, Maldraxxus needed to be able to adapt to the ever-changing environments its forces would inevitably be called to march upon.

The power to shape and alter the very landscape of Maldraxxus was granted to the Eternal One who stood at the head of the necrolords, the master strategist known as tHE PRIMUS. By his hand, the malleable flesh fields and bone spires of his realm were shaped to serve as the ideal training ground for the ultimate army.

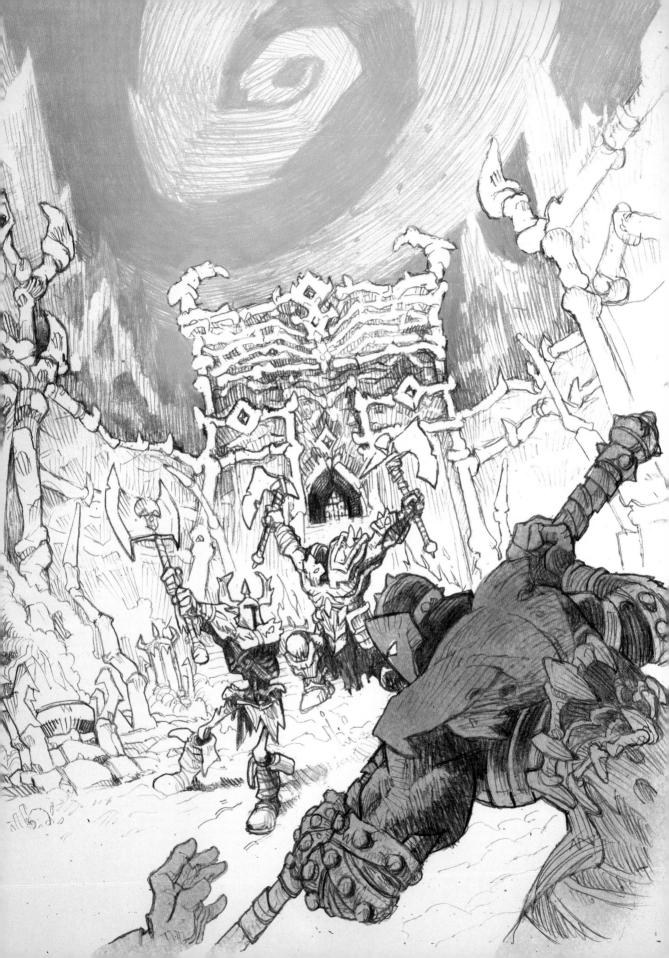

THE FIVE HOUSES

Azerothians often say that "history is written by the victors," but in Maldraxxus, that sentiment runs even deeper. To be defeated is to be forgotten.

The Primus understood that victory for his realm would not be achieved through physical might alone, that there were many subtle aspects to warfare that required rigorous methods of instruction and discipline. Thus the Primus divided his necrolord soldiers into five houses, each of which embodied what he saw as one of the five traits of the ideal champion of Death. By their very nature, each house maintained a contentious relationship with the others as they struggled for dominance and power. Sometimes this conflict took the form of heated military exercises, whereas others were a long game of manipulation and espionage. This infighting was not a symptom of a failing system, but an essential ingredient of success. Conflict was an accepted process through which the mightiest within Maldraxxus claimed and maintained their power. From it, weak leaders were struck down and supplanted by those better suited to lead their immortal armies. While effective at cultivating strength, this process also helps explain the current state of ruination these once mighty houses are found in today.

At the head of each of the five houses was placed a MARGRAVE to rule it, along with two BARONS beneath them. These positions were not places of complacency, for barons were ever striving to claim the role of margrave, just as rank-and-file soldiers sought to rise to the rank of baron. The lone constant in this sea of contention was the Primus himself; while margraves and barons rose and fell, change in Maldraxxus was ever driven by strength.

 MARGRAVE GHARMAL, House of Constructs, home of juggernauts, of physical might and intimidation

 MARGRAVE SIN'DANE, House of Rituals, home of necromancy and sorcery, of intellect and ambition

 MARGRAVE AKAREK, House of Eyes, home of subtlety and infiltration, of secrets and weaknesses

 MARGRAVE KREXUS, House of the Chosen, home of arms and armor, of tactics and strategy

 MARGRAVE STRADAMA, House of Plagues, home of toxins and poisons, of debilitation and decay

The Primus was said to have impressed one rule above all others: the rivalry that existed between his five houses must never overshadow their duty to defend the realms of Death at any cost. As a symbol of that unified purpose, one imposing structure rose above all others in Maldraxxus: the Seat of the Primus. From this ancient fortress, the Primus had crafted and unified his five houses[6] into a singular army to respond to the charge he was entrusted with by the Progenitors.

6 Only one house of the five stands and targets the new necrolord covenant. Should the covenant survive, the Ta should be ready to bolster necessary supply chains required for the rebuilding effort. Peerless profit potential is forecasted.

Though the rivalry between the houses did indeed forge five mighty armies, it seems clear that there was a fatal flaw that manifested within the ranks of the necrolords, as evidenced by the names struck from the list prior. For even before the anima drought set in and the Arbiter ceased her judgment of souls, the Primus vanished from Maldraxxus, and in his absence the rivalries between the five houses gradually grew from contentiousness to malignant treachery. Hostilities erupted, and the ensuing chaos plunged the realm into open war that resulted in the downfall of all but a single margrave. Knowing that we brokers often find opportunity within discord, I have sought to learn all I can about the Primus and the immense powers that were at his command.

The Primus of Maldraxxus was known to be the most tactical and strategic of the Eternal Ones who rule the realms of Death. His stratagems and weaponry would prove to be infallible against his every foe. One account cites that the only losses the Primus suffered were intentional, as he felt there was more to be learned in defeat than in an endless series of decisive victories. While it is true that his tactical acumen presents no measurable value to our Ta cartel (the Zo, I am certain, have a differing opinion), let us remember that the Primus was also the Shadowlands' foremost scryer of runic power and, thanks to records uncovered by the living mortals, was recently confirmed to be the devisor of the language of DOMINATION—the very force used to bind the Jailer within the Maw.

That you are hearing this message means my
suspicions proved true. Zovaal has forged his chains
into a weapon . . . and brought about my defeat.

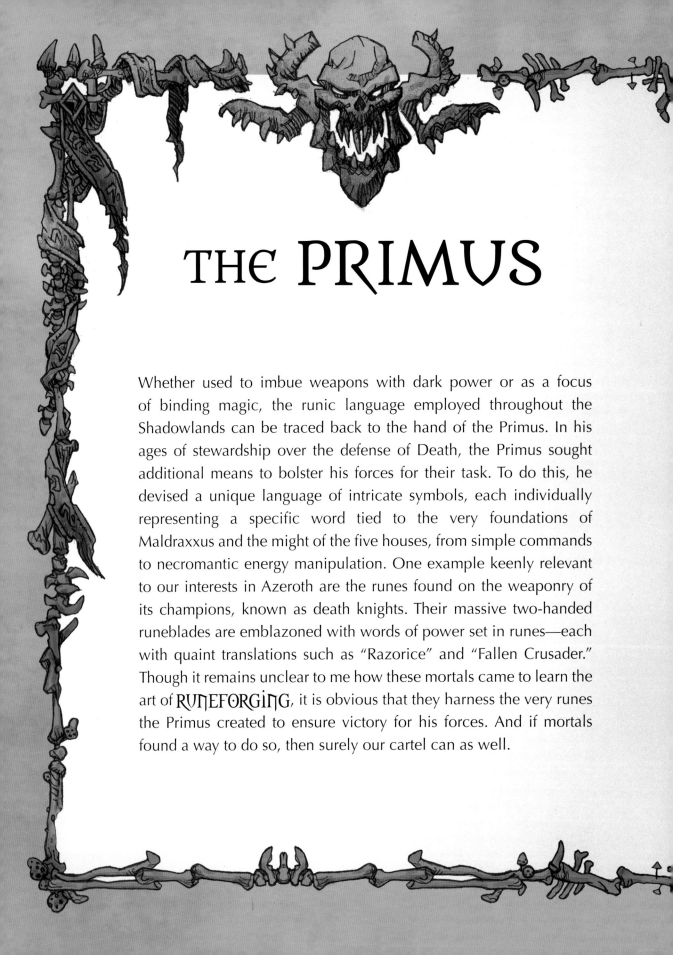

THE PRIMUS

Whether used to imbue weapons with dark power or as a focus of binding magic, the runic language employed throughout the Shadowlands can be traced back to the hand of the Primus. In his ages of stewardship over the defense of Death, the Primus sought additional means to bolster his forces for their task. To do this, he devised a unique language of intricate symbols, each individually representing a specific word tied to the very foundations of Maldraxxus and the might of the five houses, from simple commands to necromantic energy manipulation. One example keenly relevant to our interests in Azeroth are the runes found on the weaponry of its champions, known as death knights. Their massive two-handed runeblades are emblazoned with words of power set in runes—each with quaint translations such as "Razorice" and "Fallen Crusader." Though it remains unclear to me how these mortals came to learn the art of RUNEFORGING, it is obvious that they harness the very runes the Primus created to ensure victory for his forces. And if mortals found a way to do so, then surely our cartel can as well.

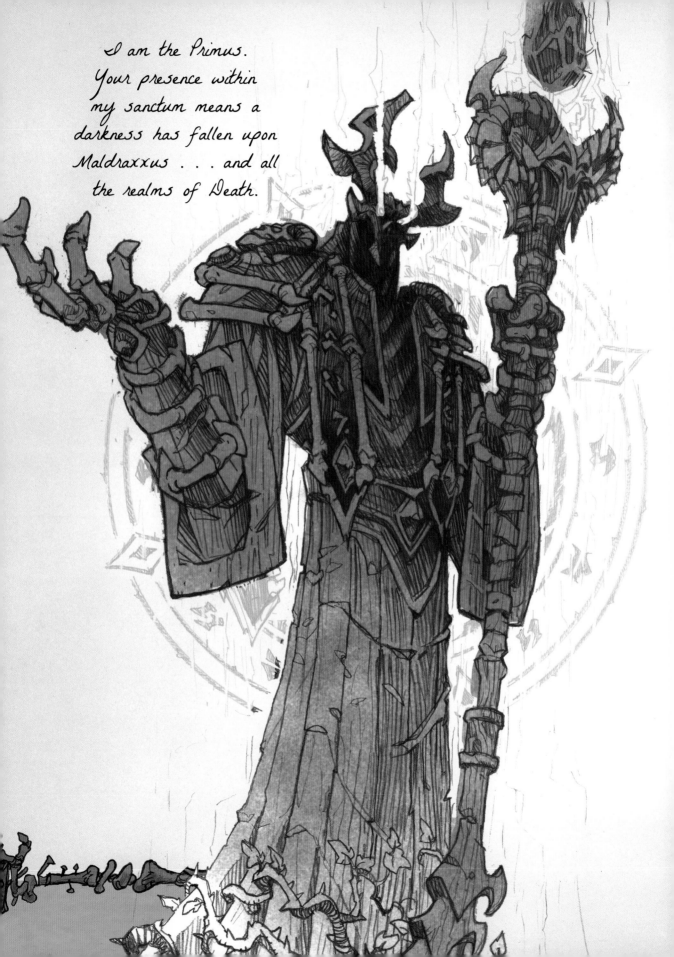

I am the Primus.
Your presence within
my sanctum means a
darkness has fallen upon
Maldraxxus . . . and all
the realms of Death.

Yet as potent as the Primus's runic language proved to be, we must speculate that an even greater force was required to bind his errant brother, ᴢ๏ᴠᴀᴀʟ. Would beings such as the Eternal Ones feel remorse at condemning one of their own for all eternity? What crime could have been committed that would warrant such a sentence? Such answers are unknowable to us, of course. What is clear is that the Primus delivered what was needed: a new runic language, one whose sole purpose was to be the utter suppression of another. The language of Domination.

For uncounted ages, the Jailer remained sealed within the Maw. Over time, the tale of his imprisonment became a legend passed down only in hushed whispers, for the mere utterance of his name was said to hold dark power. Even the usually detailed records kept by the attendants in Oribos contained only oblique references

to the events that had transpired. But when the living mortals of Azeroth were plunged into the Maw and against all odds found a means of egress from it, they shared the tale of what they had witnessed within that realm of torment. The empowered runes they saw carved upon the Jailer's visage can only mean one thing. The Primus used the language of Domination to brand the sentence of the Eternal Ones onto his brother's flesh, employing this entirely new system of magic to lock the Banished One away within what was intended to be an inescapable prison.

Domination, the most potent runic language the Primus had ever created, was meant to remain in the Maw, but the best-laid plans do often seem to go awry. We must now conclude that over the course of eons, the Jailer learned to harness the power that was meant to bind him and, with the help of willing allies, achieved the means to transcend the bounds of his prison. Intriguing that the first target for his influence was not to be found within the realms of Death, but rather the mortal world whose name has become so prominent within this tome: Azeroth. Agents of the Jailer's will forged weapons of Domination and bore them across the veil into the plane of the living, seeding the power of Death and drawing certain mortals to the Banished One's cause.

THE MORTALS OF AZEROTH IN MALDRAXXUS

While countless souls have crossed over into the infinite realms of the Shadowlands, the current state of Maldraxxus has been particularly affected by souls whose fates were bound to Azeroth. BARONESS DRAKA, who served under Margrave Krexus in the House of the Chosen, was born upon a world called Draenor, but she met her end alongside her mate after her people invaded the lands of Azeroth. Upon her soul's arrival in Maldraxxus, she was neither baroness nor of the Chosen, for she was first conscripted into the House of Eyes. I learned of her tale through a mortal who had found favor with the necrolords, a diminutive green-visaged mage of a race called goblin who was quite willing to barter this information in exchange for a few meager enchantments. It was I who achieved the better end of the bargain, I assure you.

As I have already noted, the disappearance of the Primus caused any semblance of unity between the five houses to unravel. The first casualty of this discord was the House of Plagues. An explosion of the volatile toxins that were the hallmark of the house devastated the area and left its agents destroyed or monstrously transformed, with most survivors wandering the ruins as little more than brain-addled husks. Word spread that the destruction had been accidental, but Margrave Akarek of the House of Eyes suspected treachery. Perhaps sensing doom was closing in upon him, Akarek dispatched Draka with a message to the House of the Chosen just before his own necropolis fell from the skies.

Draka witnessed the unbelievable destruction of the Eyes firsthand, using the fires of her rage to forge a new bond with the House of the Chosen in service to its margrave, Krexus.

Shortly after the living mortals first set foot into Maldraxxus, those responsible for masterminding the fall of the two houses revealed themselves; a union between the margraves of the House of Constructs and the House of Rituals made plain their intent to either conscript or destroy the Chosen's army. Outraged by this affront to the laws of the Primus, Margrave Krexus commanded his forces to rally survivors of the fallen houses and prepare an assault against the enemy margraves, but his noble purpose would ultimately be undone when Krexus was struck down by the traitorous Baron Vyraz. Leveraging the aid of a Maw Walker to gain entry into the Seat of the Primus, Baroness Draka united the necrolord covenant—whose ranks included two notable Azerothians, BARON ALEXANDROS MOGRAINE and BARONESS VASHJ— and discovered a hidden warning from the long-missing Primus. Once more the children of Azeroth find themselves crucial to current events beyond the ruined veil between Death and Life.

Baroness Draka and the other covenant leaders now oversee their united forces from the aforementioned Seat of the Primus. Just as the Primus long ago unified his five houses into a singular unstoppable force, the necrolords seek to do so once more against their enemies. The Seat had been unbreachable since the departure of the Primus, no doubt because the Eternal One did not wish for the great power and knowledge contained within to fall into unworthy hands. The hall would remain undisturbed until a Maw Walker unearthed an unfinished runeblade and was proven to embody the qualities of the ideal Maldraxxi defender.

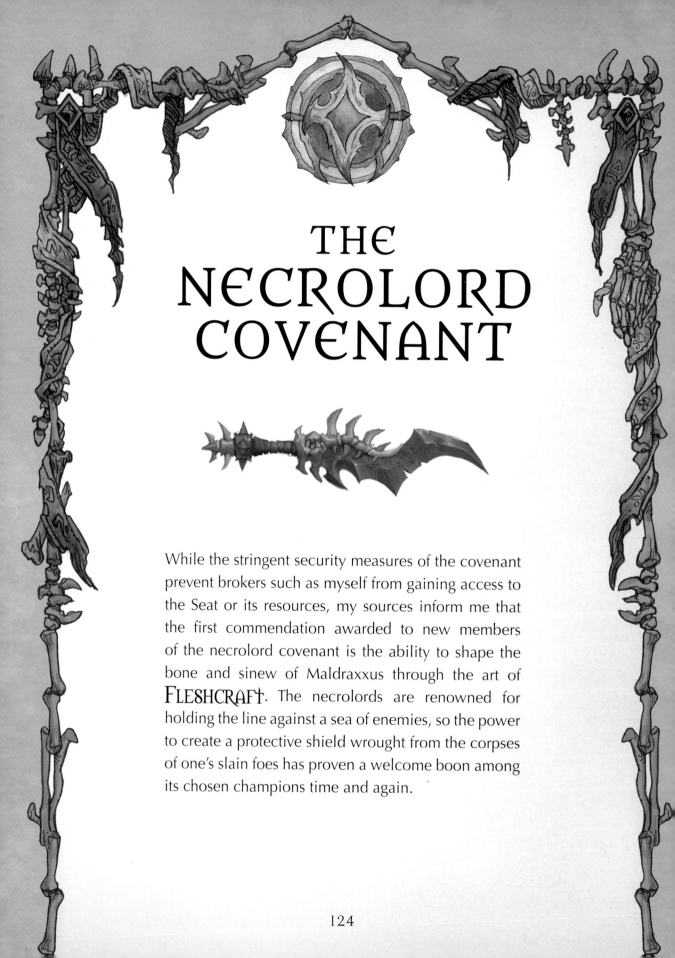

THE NECROLORD COVENANT

While the stringent security measures of the covenant prevent brokers such as myself from gaining access to the Seat or its resources, my sources inform me that the first commendation awarded to new members of the necrolord covenant is the ability to shape the bone and sinew of Maldraxxus through the art of FLESHCRAFT. The necrolords are renowned for holding the line against a sea of enemies, so the power to create a protective shield wrought from the corpses of one's slain foes has proven a welcome boon among its chosen champions time and again.

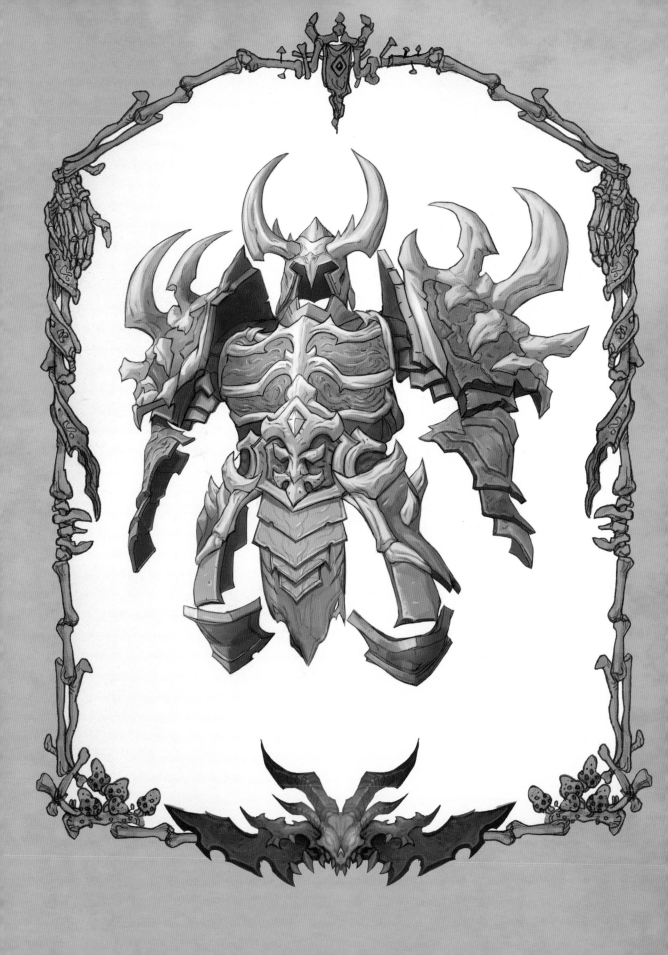

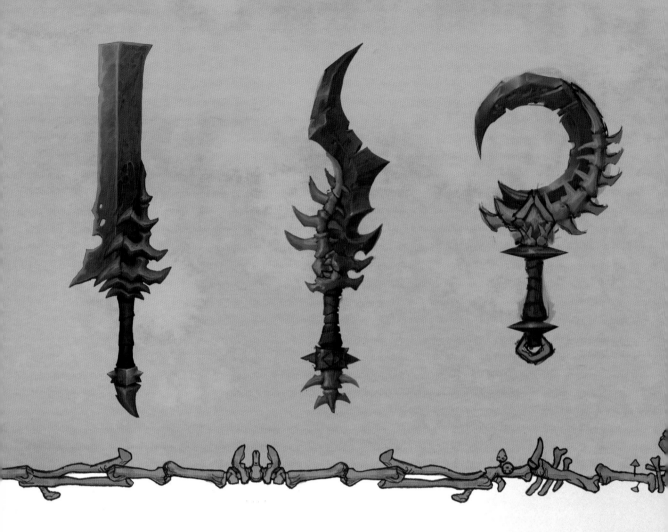

Necrolords who consider each other worthy of the honor may choose to become soulbound, a tradition upheld by all covenants within the Shadowlands. Souls deemed worthy of Maldraxxus share a camaraderie in war and draw strength and guile from those on the field around them. The soulbinding ritual of Maldraxxus opens both parties to all the triumphs and terrors faced in achieving the victories each has claimed, and this sharing of tactical knowledge makes the pair stronger—the echoes of which endure even if one of the bondmates should perish. A constrictive contract, indeed.

I have known many soulbinds, but the foremost of them all was Margrave Stradama! Her knowledge, talent, and kindness became part of who I am. Now and forever, it is a bond we share.

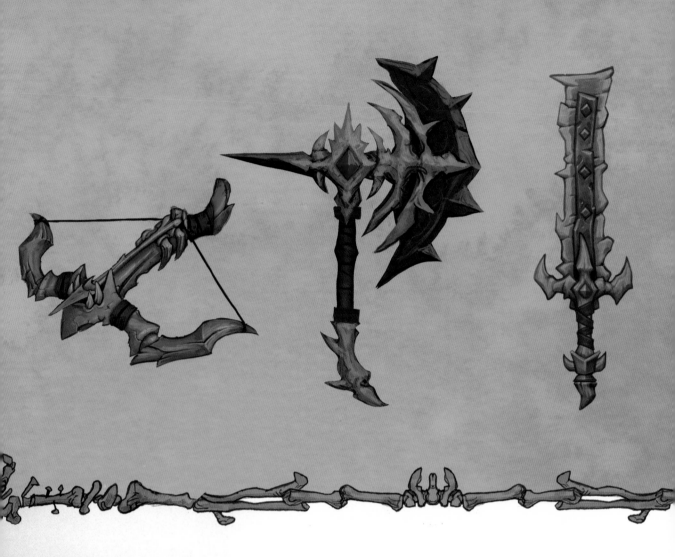

The Primus was known to be the finest armor crafter in all the Shadowlands, and he expected those he trained to produce armaments worthy of his legacy. The protection wrought by exceptional Maldraxxi smiths is made for the mighty of mind and muscle. The durability of these works of organic art far exceeds the standard fare offered by our cartel's competitors. From the legendary durability needed to withstand wilting blows to the intricate muscle fibers woven for aiding brute strength, each protective garment is tailored specifically to its champion. Our continuing efforts to secure access to Maldraxxi materials for the Ta cartel is a costly initiative, but it's one that promises to be a windfall in the conflicts to come.

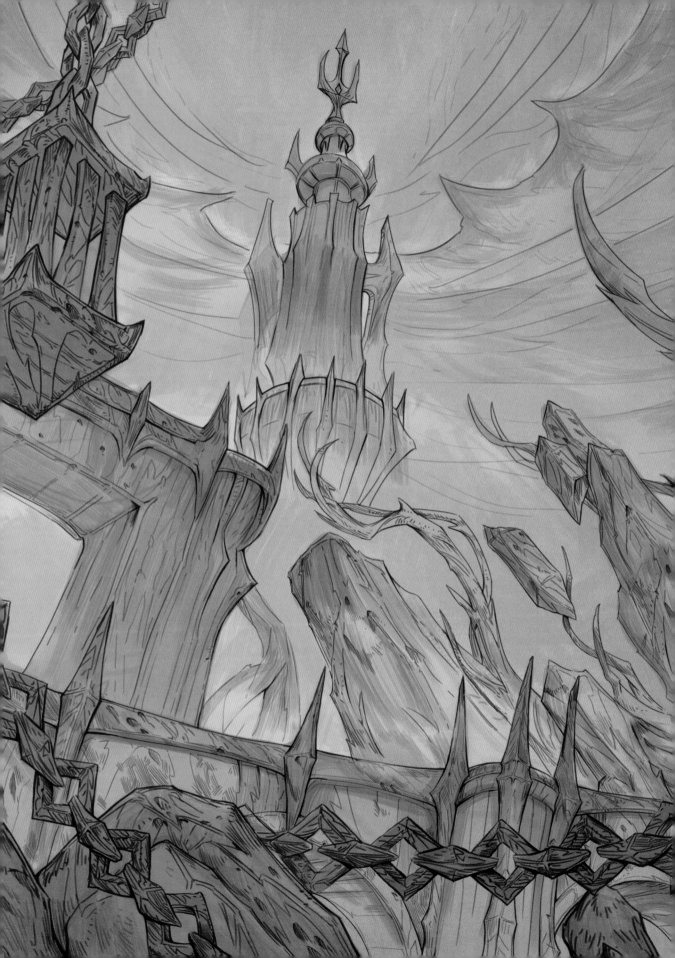

CHAPTER 8

THE MAW

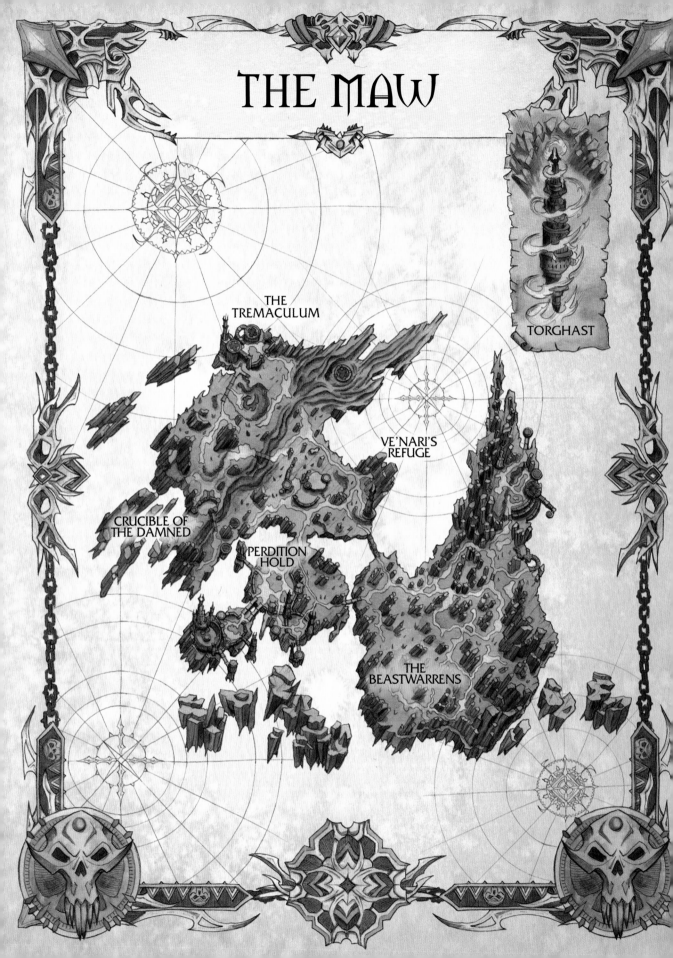

THE MAW

TORGHAST

THE
TREMACULUM

VE'NARI'S
REFUGE

CRUCIBLE OF
THE DAMNED

PERDITION
HOLD

THE
BEASTWARRENS

There is but one hope to save the Shadowlands.
The Eternal Ones must stand together once more,
before the Jailer escapes the Maw.

Having thoroughly examined the afterlives most critical to the function of the machinery of Death, the stage is now set (to borrow a night fae expression) for us to consider the darkest realm of all—the one that inspired the creation of this very tome in response to the inciting actions of the Ve cartel. Before we begin, I feel I must disclose that unlike the Ve, who plunged headlong into peril, I have not personally ventured into the Maw to confirm the accounts recorded here. While I have taken every other step necessary to ensure my grimoire's accuracy, I draw the line at thrusting myself into an inescapable prison. Fortunately, the associations I have made with the living mortals of Azeroth have afforded a bounty of invaluable information. All that is known of the Maw and its Jailer, the Banished One, was obtained through consultation and conversation with the Maw Walkers and their close associates in Oribos. Confirmation of these reports can commence once we acquire the means to reliably travel there and back again.

The Pit of Suffering

The Maw is said to be the embodiment of misery, a bleak, painful eternity that awaits the wretched mortal souls sentenced to its inescapable embrace. Little is written about this place, for no souls damned to its eternal darkness had ever escaped to tell the tale. Even the attendants in Oribos, who are easily manipulated into sharing their observations on most any afterlife, will speak only in hushed whispers about the Maw. If what they say is true, there is no redemption to be found anywhere within this abysmal place, nor hope for a soul to move on after being cast in. Each soul condemned to the Maw is twisted until nothing but an echo of their former being remains. And even that echo is broken by the Maw so that the tormented blindly serve their tormentor.

Prior to the event that caused the Arbiter to cease her judgments, the scribes in Oribos claim that relatively few souls received the irreversible edict of banishment to the Maw. After all, those with even a slim chance to atone for their crimes were sent to Revendreth, and as we have documented in our cartel's travels, there exist numerous afterlives of temporary punishment for souls who merit it. But now every soul the kyrian bear across the veil—along with their precious anima—goes directly into the Maw, a realm that was all but bereft of this resource in the past. In tandem with the infusion of a vast quantity of anima from the efforts of Sire Denathrius, his fellow Eternal One, this means the JAILER has the very lifeblood of the Shadowlands in his grasp.

This shift in power is very likely the inciting incident that spurred our Ve associates to dispatch an expedition into the Maw in a rush to monopolize its mysteries and their potential profits. Despite our rivals' head start, we of the Ta shall discover the truth behind those mysteries and learn how the Jailer not only breached the confines of his prison, but also the part he played in shattering the veil between Death and Life. Unfortunately, the ambitious Ve'nari seems to have the advantage over us, not only in terms of her knowledge of the Maw but of the Jailer's stronghold at the very center of it: the spire of infinite dread called Torghast.

Torghast

It is said that within the deepest and darkest place of the Maw is where Torghast, the Tower of the Damned, can be found. This cursed spire is where the condemned mortal souls are broken and prepared to serve their master. From his seat of power, the Jailer fully controls the newfound flow of anima and unending flood of mortal souls into his Maw.

Torghast is described as an ascending labyrinth, its ever-shifting interior reflecting both the tumultuous state of the Maw and the whims of its Jailer. The chaotic energies within are unquestionably perilous, but I have been told by the living mortals who have returned from its reaches that its powers can be harnessed to amplify their own skills and abilities. Fortunate for them, for the true horror of Torghast is said not to be its endless and directionless unfamiliarity but rather the sentinel who guards it. Those who have seen it say this nightmarish monstrosity, the TARRAGRUE, cannot be defeated. It does not tire and cannot be bartered with. It hunts its prey relentlessly and, once unleashed, mercilessly slaughters everything in its path.

Ages ago, the Eternal Ones punished our brother Zovaal for his treachery. He was bound within the inescapable Maw, to be forevermore its Jailer. Now I fear Zovaal did not act alone. I suspect he had ancient allies . . . and will seek to win others to his cause.

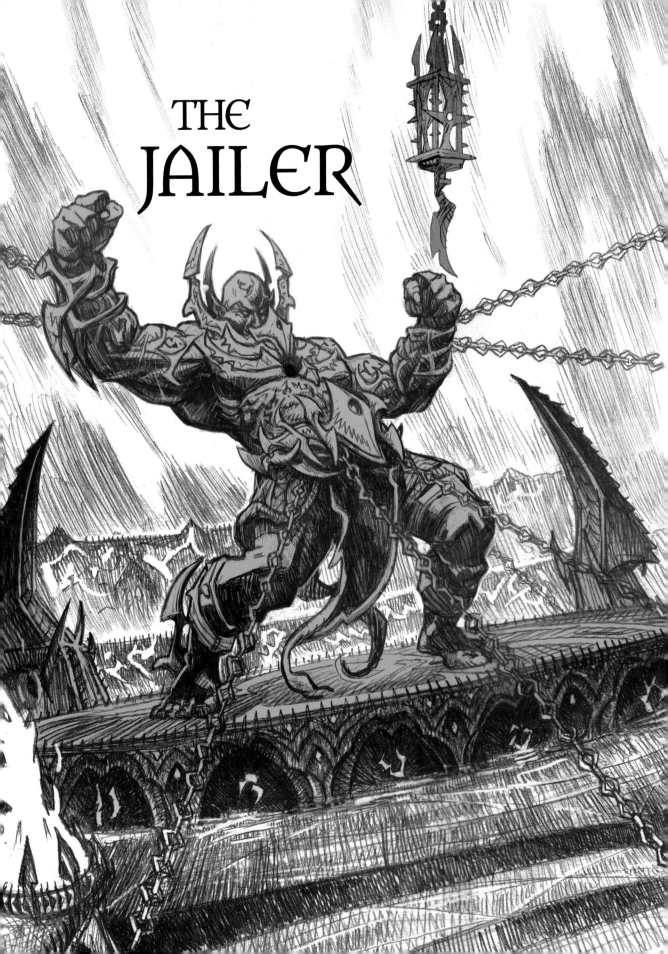

THE JAILER

So prodigious have been the effects of the Jailer's recent influence upon the Shadowlands that it seems absurd to consider that, for most of our known history, there was very little tangible evidence to show that such a being even existed. After an exhaustive search of our cartel's archives, I could produce no account that even described the Jailer's appearance, let alone his purpose beyond overseeing the damned souls condemned to the Maw. Theories and legends were all that could be found until living mortals crossed over into the realms of Death, with their inexplicable ability to escape the Jailer's grasp.

The only authentic evidence as to the Jailer's history comes from a report flittering through the halls of Oribos, itself sourced from a living Azerothian who unlocked the Seat of the Primus and uncovered a message left behind by the Primus himself. In this accounting, the Jailer—called by his true name, Zovaal—once stood beside the Eternal Ones as a brother before rising up against them. So great was the power of Zovaal that it required all his kin to unite in order to bring about his defeat. As to what caused the conflict, the Primus's message does not say, but we know with certainty that for those crimes, the combined Pantheon of Death sentenced Zovaal to become the Jailer of the one place they knew that he could never escape: the Maw.

It can truly be said that the minds of such elevated beings as the Eternal Ones are beyond a humble broker's ability to comprehend. Yet by the implacable nature with which they are said to have overseen their realms throughout the uncountable eons of the Shadowlands' existence, we must assume that the Pantheon of Death believed Zovaal's confinement to be absolute and irrevocable. The message left behind by the Primus does not cite the reason he suspected the Jailer was scheming to break free of his bonds, but the evidence must have been compelling enough to draw the master tactician away from Maldraxxus into a trap that resulted in his downfall.

THE HELM OF DOMINATION AND FROSTMOURNE

The evidence I have gathered during my writing of this tome establishes a clear pattern showing that the Banished One's plans have been in motion for some time. I refer once again to the world of Azeroth and the aforementioned entity known as the Lich King. Given the fearful tones in which some living mortals spoke of this being, you will understand my surprise to learn that one who most recently bore that title—HIGHLORD BOLVAR FORDRAGON—has been welcomed into the Eternal City of Oribos and was instrumental in rescuing several figureheads of Azeroth nobility from the Jailer's clutches. Prior to Fordragon, a human prince named ARTHAS MENETHIL claimed the title of Lich King, and before him an orc shaman called Ner'zhul. The remnants of the crown worn by all three, the Helm of Domination, is now under guard in Oribos, where the Highlord has drawn upon its residual magics (apparently at great personal risk) to spy on the Banished One and his allies.

Yet the helm was only one of the vessels of Domination; the other, a blade called Frostmourne, proved an even more insidious conduit of the Jailer's will. For not only did this weapon strike down its foes and possess the ability to raise the fallen into undeath, but it was said to draw in its victims' souls (and, we may presume, essences of a similar nature) and keep them imprisoned within the blade. Furthermore, if the account of the Forsworn kyrian Uther the Lightbringer is to be believed, Frostmourne could even shatter a soul and leave its fragments with an unhealable wound. Perhaps it is a relief to all that Frostmourne was broken in battle prior to Bolvar Fordragon becoming Lich King, theoretically releasing the souls bound within it. Again, I stress that Uther's account has yet to be verified, but the former paladin of Azeroth claims that his own soul still feels incomplete. If true, we can only speculate where the remaining fragment is being kept.

How the runeblade Frostmourne and the Helm of Domination came into the Lich King's possession—these instruments being born of the power of the Maw and essential to the Jailer's plot—has yet to be fully explained. Nor is it clear why the leaders of the Burning Legion who unleashed the Lich King upon Azeroth believed this entity to be serving not the machinations of Death, but of Disorder. One possible answer lies within a tome recently recovered in Revendreth that hints that one of the Jailer's allies, Sire Denathrius, created agents designed to infiltrate the other cosmic forces that might threaten his realm. Could these unwelcome guests in service to Denathrius have deceived the demonic hierarchy of the Burning Legion and become the instruments of the Jailer's plans on the mortal plane? Should this theory prove accurate, the implications of such a complex and long-gestating conspiracy are chilling indeed.

I have obtained two additional bits of compelling information to ponder. The first being an account sourced from a Maw Walker—delivered to me, unfortunately, after completing multiple transactions with our competitor Ve'nari—which describes a wretched entity chained within the bowels of Torghast known only as the RUNECARVER. This being claims to have no memory of its past, and in the course of restoring fragments of its memory, the Maw Walker learned that the Runecarver was, in fact, the (seemingly) unwilling architect behind both Frostmourne and the Helm of Domination.

As already noted, the runeblade Frostmourne was shattered in battle, and while it is said the fragments of the sword were later used to forge a different weapon, the death knights of Azeroth have assured me that the dark legacy of the original blade is at an end. As for the Helm of Domination, it sat upon the head of the third Lich King, Bolvar Fordragon, until his defeat at the hands of one of the Jailer's allies, Sylvanas Windrunner. Rather than donning the crown herself, she shattered the Helm of Domination to sunder the veil between Death and Life, tearing a rift into the Maw that would allow the Jailer's eye to fall upon the mortal world of Azeroth.

SYLVANAS WINDRUNNER

As inscrutable as the Jailer's methods and ultimate objectives may be, the mysteries surrounding his collaborator, Sylvanas Windrunner, appear nearly as enigmatic. How was she, a mortal beyond the veil between Death and Life, granted such a monumental measure of the Maw's power? What bitter price was involved in brokering her bond with the Banished One? Why was she trusted? Or chosen?

It seems as if nigh every living mortal I have spoken to in my research—as well as many souls who had encountered her in life—has a different (and often polarizing) perspective on the one they call the Banshee Queen. She was a hero to some, losing her life defending her homeland before being raised into undeath by the second mortal to be called the Lich King, Arthas Menethil. Prior to her unmasking as an ally of the Jailer, she served as leader of the Horde, one of the major political factions of Azeroth.

Arguably installed into power thanks to the influence of her now-known benefactor, Sylvanas repaid his investment in her by launching a merciless attack upon a rival kingdom that plunged the world into a calamitous war. One that resulted in an untold number of souls—and their anima—being delivered into the Shadowlands. And due to the current state of the Arbiter, each and every living mortal who fell fighting in that war filled the ranks of the vast army of the Jailer. Despite its unquestioned significance, Azeroth is but one among the myriad of mortal worlds contributing to the soul stream, all of which have been conscripted into the ranks of subjugation under the Jailer.

After sundering the Helm of Domination and tearing open a rift into the Maw, it was doubtless Sylvanas Windrunner who dispatched a pack of MAWSWORN KYRIAN to Azeroth to capture its key leaders. Whether this abduction and the subsequent tests the Jailer conducted on them in the Maw was strategy or merely selfish cruelty, only the Banshee herself can say. As of the scribing of this tome, all but one of those abducted have been rescued and brought to Oribos, thanks to the efforts of the Maw Walkers. The final captive is a mortal king known as ANDUIN WRYNN, one of Sylvanas's chief rivals in the war and said to be of significant interest to her. Bolvar Fordragon, the former Lich King who proved able to peer into Torghast and verify that King Wrynn yet lived, was said to be greatly troubled by the events he witnessed. As of yet, no mortal who shared in that vision has been willing to divulge its details to me.

Over the course of my research into the background of this ally of the Jailer, it occurred to me that given the timeline of events, Sylvanas Windrunner must have been the first mortal to enter the Maw and return from it. This fact would make her the original Maw Walker, a moniker used to describe those living mortals working to save the Shadowlands from its current peril. While we brokers are not known for our use of irony, I nonetheless find this matter amusing—though should I ever encounter Sylvanas Windrunner in person, I would think it best to keep such observations to myself.

The Waystone

Based on the message left behind by the Primus in his sanctum, it is clear that the Maw was intended to be an inescapable oubliette for the Jailer, along with those souls the Arbiter deemed beyond hope of redemption. Curious, then, that a horrific realm of no return was fitted with a means of translocation to Oribos: an artifact referred to as a WAYSTONE. Its very existence, as with most things in the Maw, was unknown to us until it was confirmed by living mortals. It reacted to their presence alone, before which the denizens of the Maw believed it to be useless and broken. But why was it placed there when the very nature of the Maw is such that none were ever meant to return from it?

I fear that in regard to these questions, we are left with little more than speculation. One line of reasoning suggests that the infallible First Ones placed it within the Maw to act as a failsafe. This is a highly contested theory, as it opens the possibility of souls being unjustly consigned to such a fate long before the current state of the soul stream. Another hypothesis ponders whether the First Ones could have foreseen the coming of the Maw Walkers and ensured the waystone was in place for their benefit. If this is so, then we must conclude that these mysterious beings possess a gift of foresight far beyond even that of the Eternal Ones. Yet another tantalizing possibility from these inscrutable figures of which we know precious little.

Kel'Thuzad

Time and again we have cited that out of the multitude of worlds to be found within the mortal plane, so many of the Jailer's allies have a direct connection to the one called Azeroth. One ally of the Jailer, known in life as Kel'Thuzad, is no exception.

The mortals of Azeroth confirm that prior to his final crossing, Kel'Thuzad was a talented sorcerer who increasingly grew less interested in the arcane and more obsessed with the influence of ПECROMAПCY. The path he followed led to the ouster of his lands and titles—all in service of Death and the being who taught him this power, the Lich King. Soon the exiled mage was granted vast necromantic powers by his master in exchange for his fealty.

We can only speculate whether the Jailer approved of the ambitious necromancer, but it is plausible that the Banished One was able to peer into the mortal plane and might have come to see Kel'Thuzad as a means to extend his influence deeper into Azeroth. Kel'Thuzad was slain in fulfillment of this service, but his spirit had already been prepared to ensure the furtherance of certain plots set in motion by the Lich King.

Reborn as a lich, Kel'Thuzad's soul was anchored to an intriguing necromantic artifact of Maldraxxi origin known as a phylactery—a vessel that ensured he could rise again after death in service of his master. While this enhancement bought Kel'Thuzad time and power, eventually the end comes for every mortal existence. After the destruction of his phylactery, his destination in the realms of Death was determined by the Arbiter to be Maldraxxus—a fitting assignment, considering his great ambition in mortality. (Though given how pivotal this mortal would prove to be to the Banished One's schemes, we must consider the possibility that the Arbiter's judgment was somehow manipulated.)

Upon his arrival among the necrolords, Kel'Thuzad was inducted into the House of Rituals and wasted little time proving his worth. He was rewarded for his preternatural talent in necromancy by rising through the ranks of the house at a record pace, thanks to secretly receiving the support of substantial stores of anima from allies in Revendreth—further evidence that the lich was embroiled in the Jailer's plans from the outset. Soon claiming the rank of baron, Kel'Thuzad played upon the long-festering distrust between the houses to pit them against one another. One record cites his direct (and now proven successful) manipulation of Margrave Sin'dane and Margrave Gharmal to sabotage the House of Plagues and bring down the House of Eyes.

Though the lich's deception was expertly concealed, it is now clear that Kel'Thuzad whispered in the ear of his margrave to inspire the necrolords' attack upon Bastion. The Jailer's interests were best served by destabilizing the covenants of the Shadowlands, turning them against one another to prevent them from unifying against him. Kel'Thuzad's treachery was exposed too late, and it is said the Jailer sent his agents to free him from the necrolords' custody. Perhaps he has a part to play in the next stage of the Jailer's attempts at achieving emancipation from the Maw.

Mueh'zala

As I researched the funerary rituals of Azeroth's native populations, I learned that the first troll tribes worshiped numerous deities they referred to as loa. While these spirits of nature are, as we know, tethered to Ardenweald, one among them possessed a spirit realm of his own, a place perched upon the precipice of the Shadowlands that the trolls referred to as the Other Side. His name was VEETAY NO MUEH'ZALA. According to stories passed down through countless of their mortal generations, he was a fearsome and vindictive god, demanding living sacrifices and brutal displays of reverence. Even after the conclusion of their mortal lives, Mueh'zala feasted upon their fear and despair, hoarding these souls within his necropolis rather than allowing his supplicants to pass on into the infinite realms of the Shadowlands.

As the ages passed, the primitive troll settlements gave way to a thriving civilization—one with little need for a loa whose only interests were cruelty and death. Clever as he was, Mueh'zala must have realized that a loa without worshippers was doomed to fade into powerless obscurity, so he took measures to ensure his legacy would be preserved.

The loa appeared before one of his priests, a loyal follower named BWONSAMDI, and offered him a deal. Mueh'zala would make Bwonsamdi his successor, giving him control of the Other Side and elevating him to be the trolls' new loa of death—one better suited for the changing times. In exchange, Bwonsamdi would continue to deliver a regular tribute of power and influence to his benefactor. Where the ambitious priest saw the deal as the fruition of his hard work, the loa saw a puppet unaware of the severity of the bargain he had just accepted from his new "boss."

It appears that this arrangement remained a satisfactory one for both sides until the breaking of the Arbiter caused all souls to plummet into the Maw. Rather than subject his loyal followers to such an undeserved fate, it seems Bwonsamdi used his power to tether them to his necropolis, keeping them out of the Jailer's clutches—and away from Mueh'zala as well. Outraged at this defiance, Mueh'zala invaded the Other Side and held his former priest captive, until the crafty Bwonsamdi was aided by living mortals and was able to turn the tide and regain his freedom.

It was in the course of the ensuing battle (and by way of long, meandering diatribes spouted by each of the vociferous loa) that it was revealed that Mueh'zala had long been in league with the Jailer. It was he who had brokered the bargain with Odyn in which the titan keeper was allowed to peer into the Shadowlands and observe the kyrian, trading one of his own eyes to the loa in exchange for the power to make winged soul-bearers called Val'kyr. Why the Jailer desired to possess the titan-forged eye is unclear, and its fate thereafter is unknown.

Mueh'zala is, as of this writing, in Bwonsamdi's custody. Despite this captivity, so long as Mueh'zala exists, he remains a considerable threat.

Helya

While what information I have gathered concerning the Jailer's allies has been immensely challenging to come by, learning of the one called Helya has been a relatively simple matter in comparison. Not only are the living mortals from Azeroth quite familiar with her background (and only too happy to brag about their previous victories over her), but extensive details have been compiled about her existence by various servants of the titans. As with all information gleaned from voices sympathetic to the Pantheon of Order, I urge caution when deliberating its veracity. The biases of the titan-bound underlings are obvious, so while the broad facts of what follows can be considered accurate, please afford the details a wide margin of prejudicial error.

After the haughty Odyn traded an eye for the knowledge he needed to create his version of the kyrian from Mueh'zala, he was furious to learn that none of his followers would willingly undergo the transformation into Val'kyr. Their archive cites that Helya would become the first Val'kyr against her will, her titan-forged body shattered and her spirit twisted in the process. The immense suffering she must have endured in the ritual, combined with the pain of Odyn's cruel betrayal, filled her with hatred for the keeper she was now forced to serve. When at long last she was freed from Odyn's shackles, she turned her immense powers against him by sealing him away within the Halls of Valor. Then Helya, a powerful sorceress skilled at shaping the fabric of reality, fashioned a dark realm on the precipice of the Shadowlands she called HELHEIM, in which she built up her own forces of Kvaldir and plotted vengeance.

Although not detailed in the records of the titan sympathizers, the mortals who ultimately defeated Mueh'zala state that the loa claims he had a hand in drawing the bitter Helya over to the Jailer's cause. If true, then she would likely have been acting on the Banished One's behalf for some time.

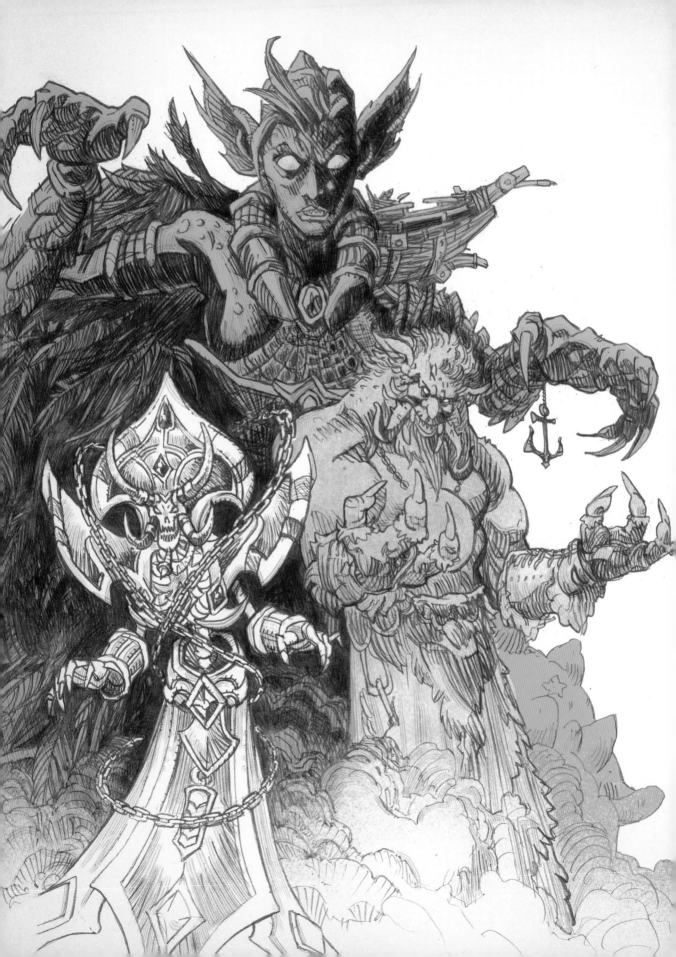

CHAPTER 9

THE FIRST ONES AND THE GRAND DESIGN

I believe it demonstrates the unlimited creativity of the First Ones. They made all things and blessed us with the Purpose.

Since we brokers first set out from our realm of origin upon our great barge cities that navigate the currents of the In-Between, we have been driven, first and foremost, by one goal: to learn the truths of the First Ones and lay claim to their ancient secrets. The journey began by seeking centers of knowledge that legends tell us were shaped by their hands, such as Oribos, Baraneth, Nirem-Ahn, Korthia, and more. In some cases, we were successful; in others, we continue our search. But even when we found such destinations, every hard-gleaned answer we uncovered led to new questions exploding like fractals before our very eyes.

QUERIES OF THE BEYOND

Whatever exquisitely rare traces the First Ones left behind are only fragments of a much larger puzzle, one that seems almost sentient, like a lock that shifts its tumblers when in danger of being opened. That is, perhaps, as sound an explanation as any when it comes to understanding why their mysteries always stay so tantalizingly out of reach. While few tangible facts are known about these shapers of the cosmos, one truth is paramount: whoever is first to harness the power of these mystical beings shall become the most influential broker of all cartels, forevermore.

To this day, Overseer, I maintain my stance that it was a mistake to allow Cartel Al to outbid us on leading the expedition to seek the SEPULCHER. We of the Ta are far more measured in our approach, and I am confident we would have already achieved success instead of tumbling into mishap like the Al. I do not wish to turn this tome into an airing of grievances, so having stated my concerns, I will speak no more on the subject and instead focus on our path forward.

The archives in Oribos, as well as the singing stones of Nirem-Ahn, confirmed that it was the First Ones who were the Progenitors not only of the Shadowlands but of the very fabric of all realities. The great cycle between Death and Life, as well as the lesser pendulums that swing between Light and Shadow, Order and Disorder—all were conceived and put in place by the First Ones, along with the pantheons that embodied their influences. And hung in the midst of these fundamental powers is a vast plane of mortal worlds ripe with souls born to serve the cycle, a magnificent pattern of grand design, flawless and endlessly intricate.

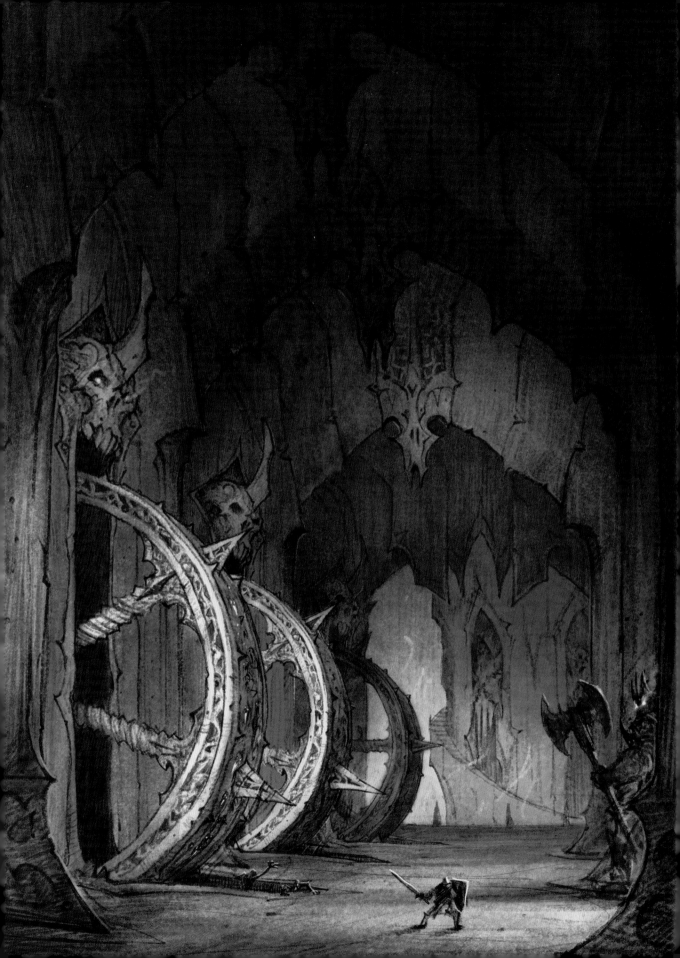

Six forces existed in strife. Well, not strife in the way one such as you or I would see it. Opposition, surely, but whether malignant or benign is unclear. There was imbalance, until there was a need for something more. They came together (or were brought together, depending on how one interprets the fractal) and gave form to their design. Forged? Scribed? Shaped? The exact word is elusive. Each gave a portion of themselves, and thus the pattern was drawn. It is from here that the language becomes clearer.

With a framework in place, all that we now comprehend came to be. As if reality were nothing more than a fungus growing upon the frame. Six forces now in balance, and from their intersections arose others. A simple structure, growing infinitely more complex.

REFINED COSMOLOGY

In the course of my research on the works of the First Ones, a living soul from Azeroth (who purported to be a scholar of some renown) showed me a tome containing an elaborately painted illustration she claimed to be an accurate representation of how the cosmic powers related to one another. I must say, despite the extensive training I completed in order to interact favorably with the mortal races, it was all I could do to muffle my derisive laughter! Instead, I patiently asked questions about the origins of this so-called "cosmology" as if I were hanging on every rambling word from the scholar's lips. When I learned that this woeful miscalculation of a chart had been passed down through the hands of her world's titan-forged races, it told me all I needed to know about the absurdity of the tome to which she clung so zealously. Why, every word within was chosen so as to look favorably upon the titans, as if the Pantheon of Order were the architects of a flawless cosmos! How typical of their kind to claim credit for that which they did not build but inherited. As has been well documented, the language of the titans uses the same word for "created" as it does for "Ordered." Such blatant hubris!

I briefly considered sharing with this self-styled scholar our own cosmology, painstakingly researched by the finest minds of our combined cartels, designed to impartially relate the foundational truths of the cosmos. In the end, I realized the mortal would fail to grasp its subtleties, so rather than waste further effort, I thanked her for sharing her "wisdom" and sent her on her way. In the interest of completeness, I am including our CORRECT cosmology map here for reference.

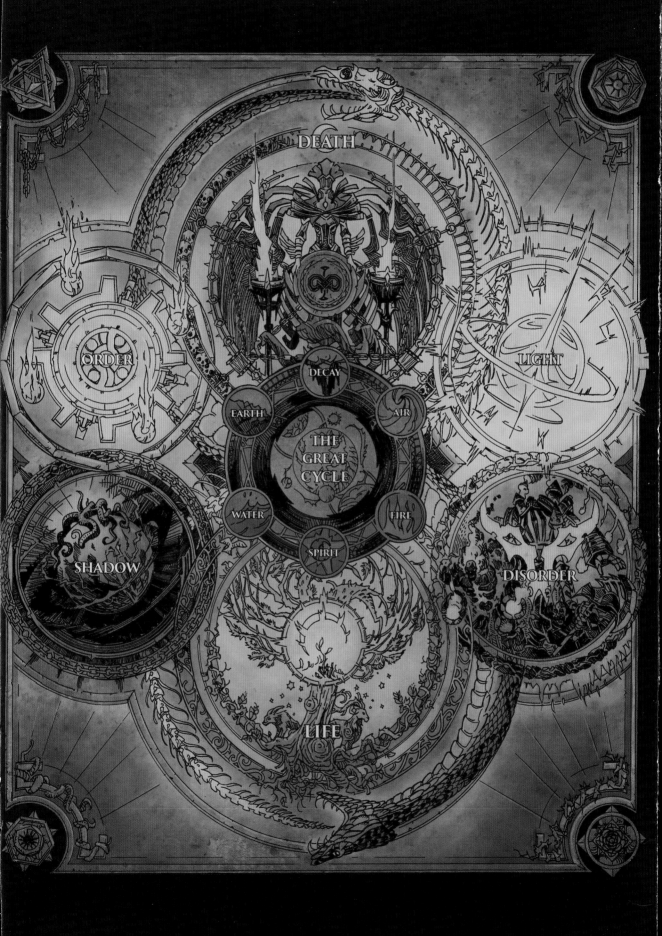

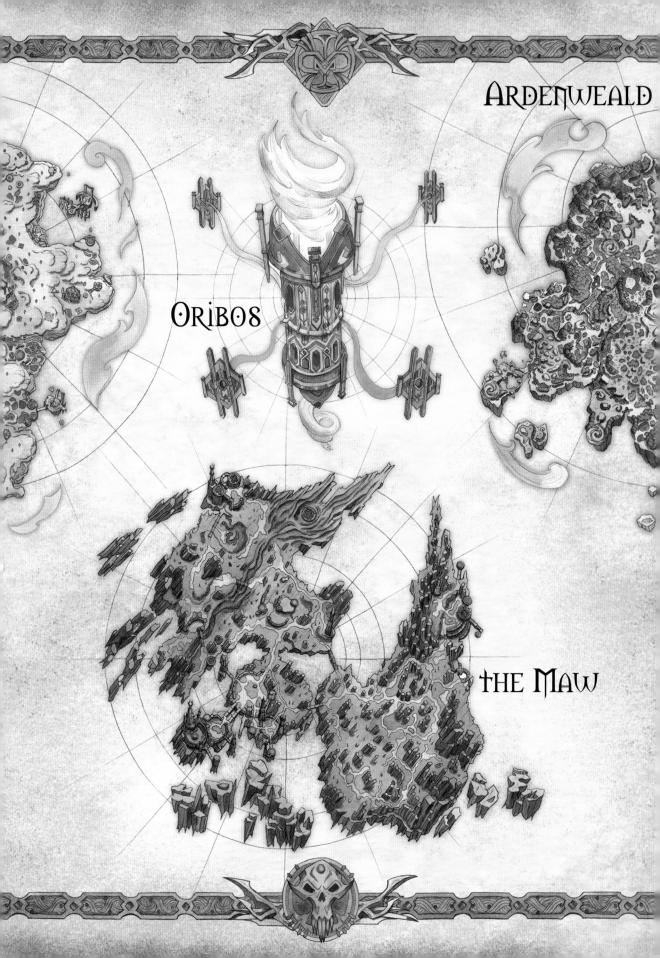

ARDENWEALD

ORIBOS

THE MAW

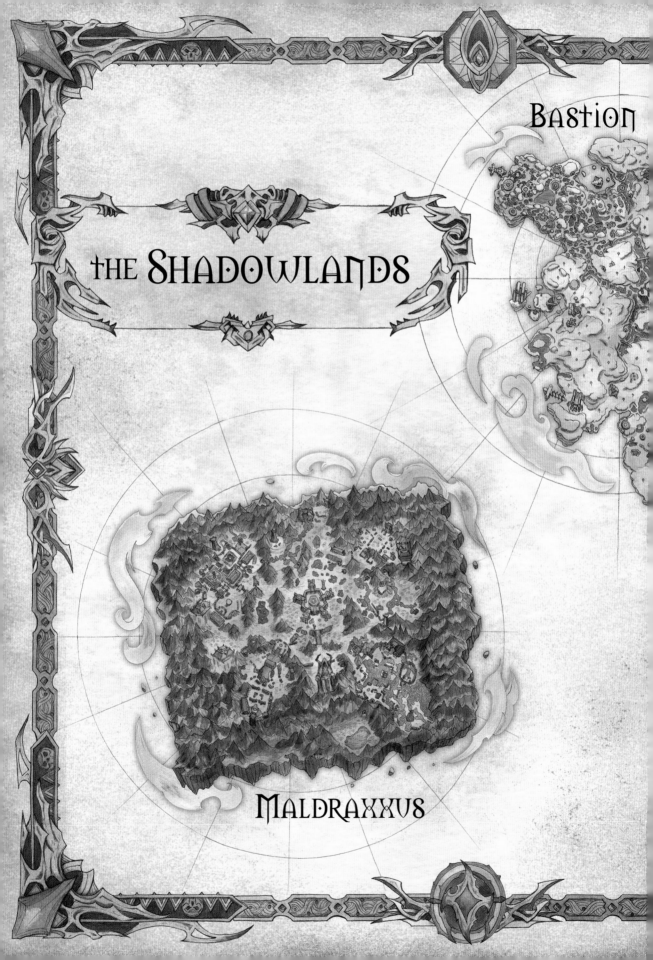

the Shadowlands

Bastion

Maldraxxus

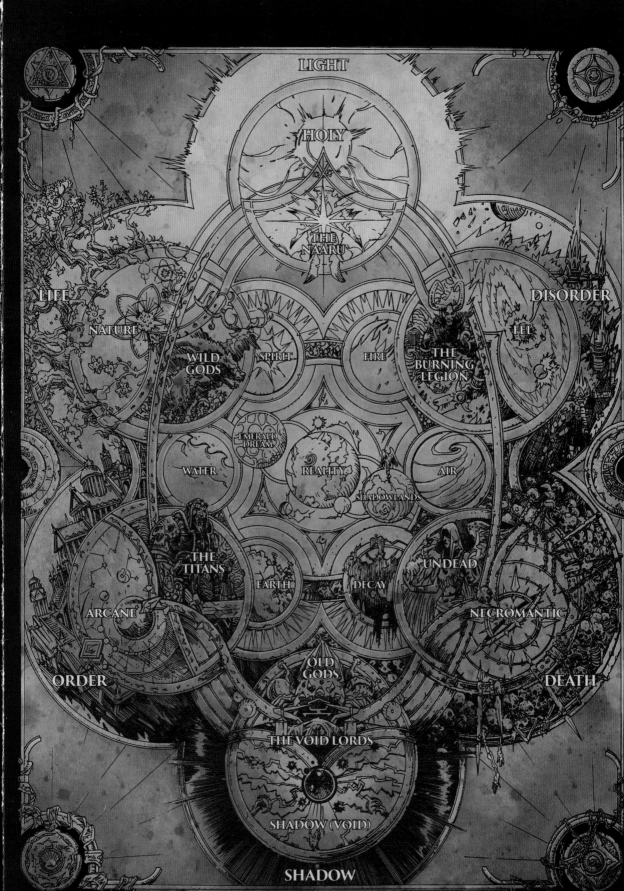

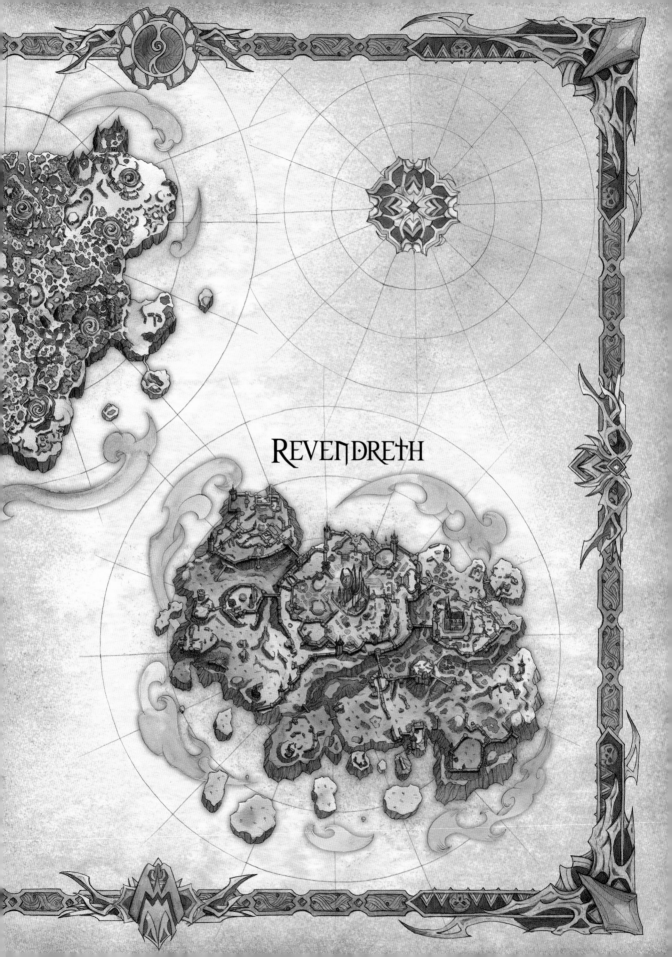

REVENDRETH

THE MYSTERIES OF THE FIRST ONES

While the evidence of the First Ones' wisdom is all around us, we know precious few immutable facts about these Progenitors. When they first walked this cosmos, whether they still do, or if the measure of their existence ended in ages long past— all are mysteries to which we have no answers. A fragment of a word here, a bit of geometry there—for all the vast knowledge we brokers possess, compared to the First Ones we are like gormlings at the feet of the Winter Queen.

I can say with confidence that you, Overseer, must have been as intrigued as I by the promising initial reports delivered by Al'firim on his journey to locate the Sepulcher of the First Ones. The fact that he decoded any of the glyphs at all was more progress than had been made in many ages of study (though whether "zereth" is best translated as "keystone" or "cornerstone" remains a subtle, yet ongoing, debate).

The language of the First Ones seems to shift and grow as I find greater depths within it. I have no doubt that further meanings will reveal themselves as the glyphs and geometry of this fractal tongue become more known to me.

But sadly, as the trek dragged on and their search meandered from afterlife to afterlife and through the remotest byways of the In-Between, each subsequent dispatch from the Al expedition contained alarmingly less coherence. "The Mad Scribe" was how they spoke of him in the trade halls of Tazavesh. We have known others of our kind who have surrendered their intellects to the great mysteries, and as many cycles passed without further contact from the expedition, it grew ever more certain that AL'FIRIM was destined to become another casualty of the fractals, a madman lost to a wilderness of incongruities.

The deeper I delve into the mysteries of the Progenitors, the less I believe Al'firim was as mad as his cartel labeled him to be. The Al seem all too eager to discredit the research they have archived on his behalf and are quick to ascribe his disappearance to a seemingly troubled condition. While the popular opinion that the Al expedition met an unfortunate end is, I admit, the likeliest outcome of the various possible scenarios, I cannot help but wonder if this "mad" individual leveraged his unique perspective and succeeded where all others had failed: locating the Sepulcher of the First Ones. Rather than coming back to us empty-handed, perhaps Al'firim simply cannot yet return for the sheer volume of knowledge that has been revealed to him. The truth of this matter, like so many others, remains to be discovered.

Overseer Ta'readon:

Many things remain uncertain about the Shadowlands and the fate of the living mortals who have arrived within its infinite realms. However, the facts collected in the assembly of this grimoire represent undeniable evidence that these Azerothian adventurers did not come here merely to plunder the treasures of the afterlives they tread; rather, they risk their own existence to safeguard them from those with their own malicious desires and designs for Death.

Upon review of the tales transcribed in this grimoire, I urge you to consider the truths they bring into focus:

 Of all the worlds in the mortal plane, it is clear that Azeroth is of particular interest to the Jailer and his allies. Examples of this fixation are cited throughout this tome, and while we do not yet understand the reasons or implications of this truth, we must assume that this world plays a pivotal role in the Banished One's ultimate objectives.

 The living children of Azeroth may have crossed prematurely into the Shadowlands, yet they discover and unlock its intricate mysteries time and again at an accelerated pace, whereas we native truth-seekers have often remained stymied in our own research. They possess a freedom of mind and fate that we denizens of Death seem to lack.

 The champions of Azeroth have successfully challenged the immutable ways of the afterlives they travel, restoring the strength of the four covenants and bringing unity where once there was only division. While there remains much to be done, we cannot underestimate the value of the opportunities their intervention has afforded us.

 The Maw and the power of its master continue to grow. Given their demonstrable history of an almost preternatural ability to claim victory in the face of certain defeat, these heroes of Azeroth may represent our greatest hope of successfully thwarting the Jailer's campaign. We brokers must make every effort to ensure the future they forge is one that aligns with our own goals and aspirations.

I must admit that this grimoire is woefully inadequate in providing an exhaustive account of the full rites of all races of Azeroth and what the living are truly capable of in Death, but I remain exceedingly confident that this tome has sufficiently proven that this mortal world, Azeroth, should ever be at the forefront of our minds and machinations. And that by their hands the Shadowlands have been forever changed.

When the initial reports of the Ve breaching the Maw were confirmed, many of our family (you will forgive the mortal shorthand, but I confess a growing fondness for it) lamented the missed opportunity, particularly as we see Ve'nari continuing to reap the rewards of her dealings with the Maw Walkers. To ensure our cartel not merely achieves parity but in fact rises to the forefront of profitability, we must act even more boldly than our Ve rivals. I propose that we set aside the monumental risks and justifications that would inevitably frustrate our progress and resolve to claim a market that has previously been considered impossible for our cartel to engage: the mortal plane.

Our window of opportunity, in the form of the ruined skies of Azeroth now connected to the Shadowlands, may not remain open indefinitely. When you come to recognize the same potential I do, I trust I will be found standing among your chosen pathfinders.

Yours in future ventures,

Ta'lora

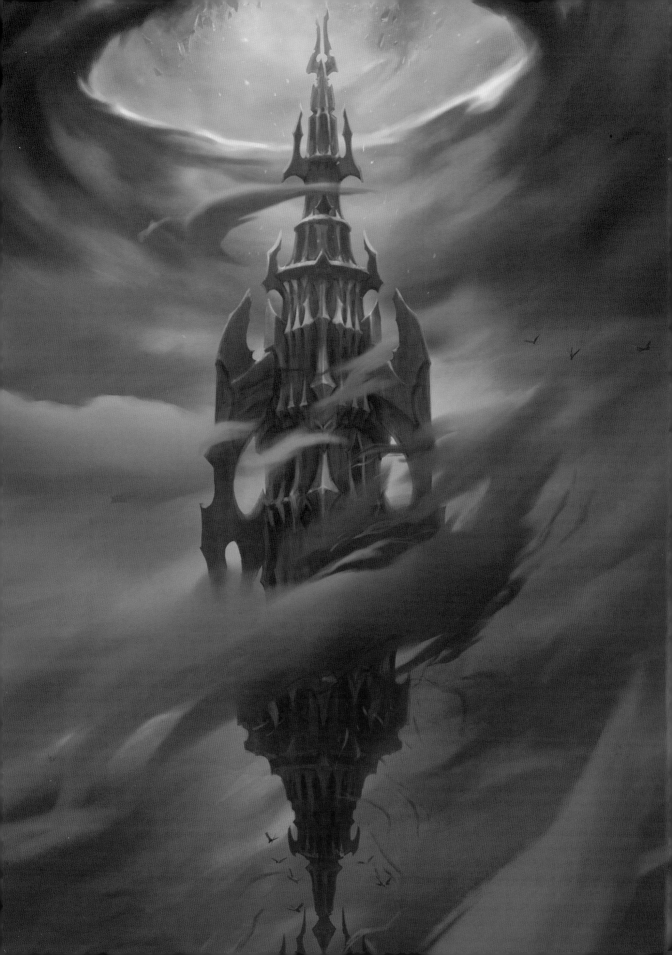

ABOUT THE AUTHORS

Sean Copeland

Sean Copeland is the principal historian of Story and Franchise Development and one of the luckiest loremasters in the world. In his fifteen years at Blizzard Entertainment, Sean has authored, edited, designed, directed, chronicled, debated, performed, and been relied upon for his guidance in shaping the award-winning Diablo, Hearthstone, Heroes of the Storm, Overwatch, StarCraft, and Warcraft franchises.

Steve Danuser

A veteran of nearly two decades in game development, Steve Danuser leads narrative design on the World of Warcraft team. He develops a wide variety of story-driven content, working with the game's quest and dungeon designers, Blizzard's cinematics group, and the company's Story and Franchise Development team on the characters and story lines that drive the game.

When Steve is not writing epic stories for Blizzard, he likes to dabble in photography, specifically landscapes and wildlife, and cooking, where he continues his dual quests to sear the perfect steak and bake the ultimate homemade pizza.

CREDITS

Written by **Sean Copeland and Steve Danuser**

Illustrated by **Francesca Baerald, Gabriel Gonzalez, Joseph Lacroix, Jimmy Lo, Mats Myrvold, Dan Hee Ryu, Lianna Tai, and Gustav Schmidt**

Additional illustrations by **Laurel Austin, Calvin Boice, Christopher Chang, Cole Eastburn, Ariel Fain, Gabriel Gonzalez, Cody Harder, Jay Hwang, Jungah Lee, Jimmy Lo, Servando Lupini, Matthew McKeown, Mats Myrvold, Jay Nam, Natacha Nielsen, Matthew O'Connor, Gustav E Schmidt, Mongsub Song, Jordan Powers, Kelvin Tan, Chris Thunig, Ashleigh Warner, Thomas Yip, and Brian Youn**

Edited by **Allison Avalon Irons**

Designed by **Betsy Peterschmidt**

Produced by **Brianne Messina**

Lore Consultation by **Justin Parker**

Creative Consultation by **Raphael Ahad, Sarah Arellano, Ely Cannon, Korey Regan, and Anne Stickney**

BLIZZARD ENTERTAINMENT

Vice President, Consumer Products: **Matthew Beecher**

Director, Consumer Products, Publishing: **Byron Parnell**

Associate Publishing Manager: **Derek Rosenberg**

Director, Manufacturing: **Anna Wan**

Senior Director, Story and Franchise Development: **David Seeholzer**

Producer: **Brianne Messina**

Lead Editor: **Chloe Fraboni**

Editor: **Allison Avalon Irons**

Book Art and Design Manager: **Betsy Peterschmidt**

Historian Supervisor: **Sean Copeland**

Senior Historian: **Justin Parker**

Associate Historian: **Madi Buckingham**

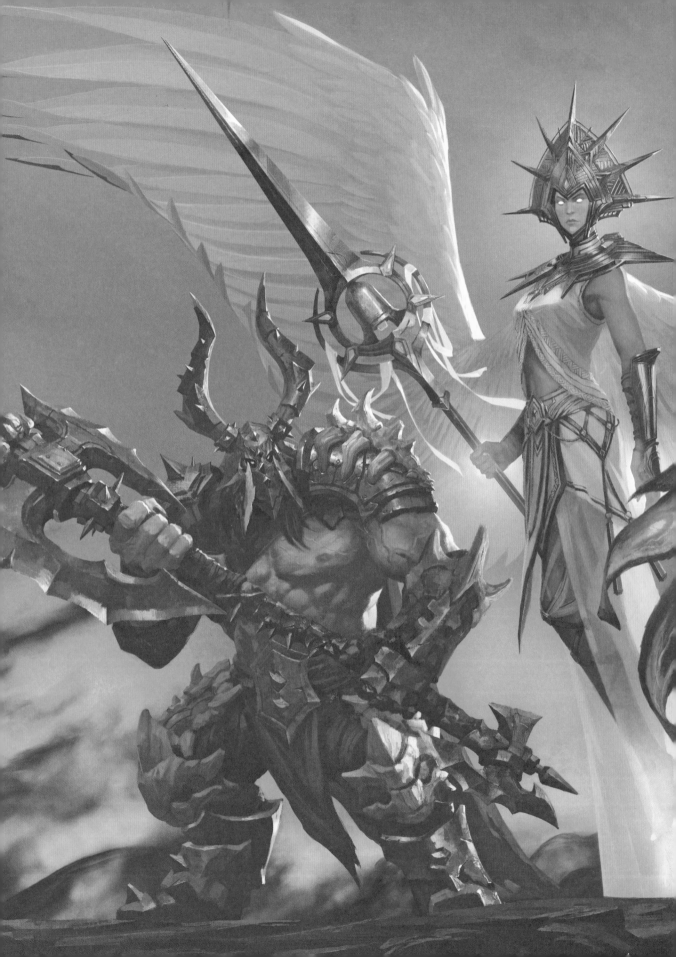